POSTCARD HISTORY SERIES

Bloomington-Normal

IN VINTAGE POSTCARDS

Front Cover Picture: **ILLINOIS WESLEYAN UNIVERSITY.** The 1933 "Little Nineteen Champions." See page 72 for more information.

Back Cover Picture: **COURTHOUSE.** Following the burning of Bloomington's third courthouse in the fire of June 1900, the construction of the fourth courthouse was completed in 1903. In December 1976, the courthouse proceedings were moved to the new Law and Justice Center on West Front Street. The former courthouse is now the home of the McLean County Historical Society.

POSTCARD HISTORY SERIES

Bloomington-Normal

IN VINTAGE POSTCARDS

Elaine J. Taylor

ARCADIA

Published by Arcadia Publishing,
an imprint of Tempus Publishing, Inc.
3047 N. Lincoln Ave., Suite 410
Chicago, IL 60657

Printed in Great Britain.

Library of Congress Catalog Card Number: 2002105015

For all general information contact Arcadia Publishing at:
Telephone 843-853-2070
Fax 843-853-0044
E-Mail sales@arcadiapublishing.com

For customer service and orders:
Toll-Free 1-888-313-2665

Visit us on the internet at http://www.arcadiapublishing.com

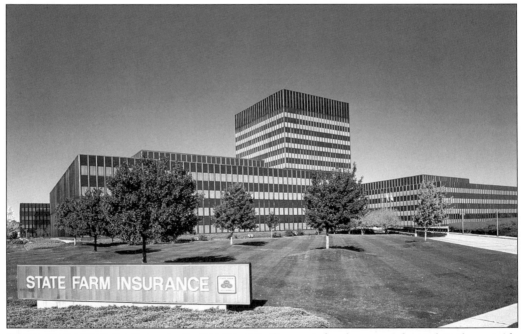

STATE FARM MUTUAL INSURANCE COMPANIES. Corporate headquarters is located on the east side of Bloomington on Veteran's Parkway. The building was completed and opened for business in the summer of 1973 and cost $30.9 million to build. State Farm is the largest automobile and homeowner's insurance company and is also the county's largest employer with 16,911 employees. (Copyrighted, State Farm Mutual Automobile Insurance Company. Used by permission.)

CONTENTS

ACKNOWLEDGMENTS

While researching this book, I had a number of "information finders" and without their assistance, this book would not have been possible. My thanks to Reverend Jim Bell, the staff of the Bloomington Public Library, Tina Crow, the staff of the McLean County Historical Society, *The Pantagraph*, State Farm Insurance Companies, and Carol Struck.

Also, it was a pleasure working with Jessica Smith of Arcadia, as we completed the steps necessary to bring this finished product to your hands.

Finally, I would like to say a special thanks to my husband Richard (Bud), son John, and daughter Karen for their assistance, patience, and encouragement.

All the pictures featured in this book are from postcards owned by Elaine Taylor.

INTRODUCTION

For me, postcard collecting began when I was a child. The minister of our church, as well as family and friends saved postcards for me. After moving from Kewanee, Illinois to Bloomington, I added postcards of McLean County to my collecting. For a person interested in history and postcards, what better way to learn their region's history than to collect views of the area? The postcard views in this book are from a variety of sources such as auctions, postcard shows, fellow collectors, friends, and estate sales.

One of the advantages of postcard collecting is you can collect cards on any subject that interests you. For example, your hometown, occupation, animals, national parks, state capitals…the list is endless. It is also a hobby families can share. My husband, Richard (Bud), collects postcards on a variety of subjects. My son John collects worldwide mining and mining-related postcards. My daughter Karen collects postcards with seashells, koalas, and Girl Scouts. If you think you would like to be a deltiologist (postcard collector), choose a topic that interests you, read books on the subject, and attend postcard shows. Let me caution you that your collection will expand rapidly as you discover new subjects—but you will have fun doing so!

One
GREETINGS

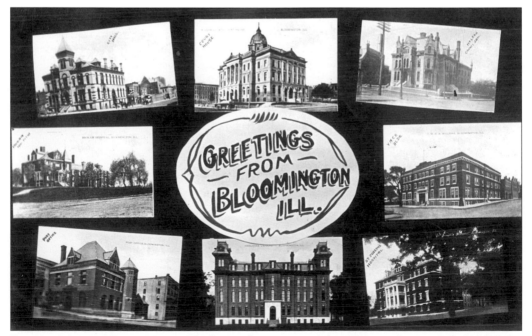

BLOOMINGTON MULTI-VIEW. Clockwise from upper-right: McLean County Jail, Y.M.C.A., St. Joseph Hospital, Illinois Wesleyan University, Post Office, Brokaw Hospital, City Hall, McLean County Courthouse.

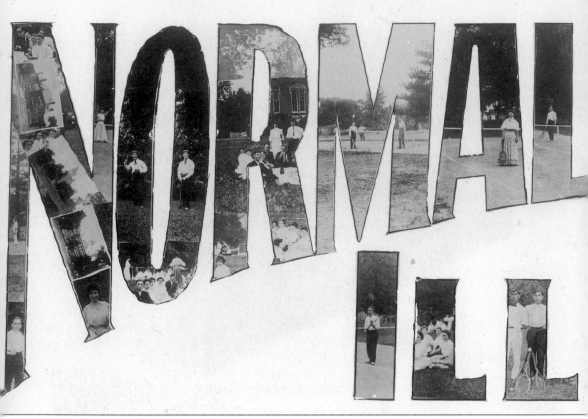

Normal Multi-View. Shows various buildings and sports at Illinois State Normal University: croquet, baseball, tennis, picnic, training school, Cook Hall, and Old Main.

Two
ADVERTISING AND BUSINESS

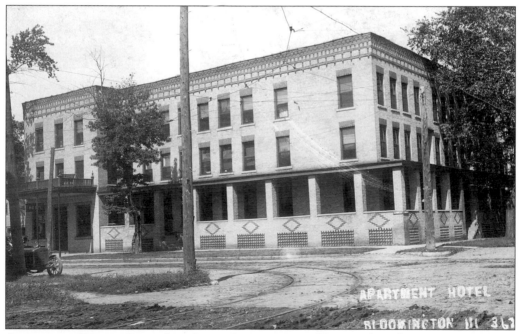

APARTMENT HOTEL. Located on the northwest corner of Front and Gridley Streets at 310 East Front Street, this hotel sprang into existence because of the shortage of rooming facilities after the fire in 1900. It was built by Henry Dooley and was both an apartment building and a hotel. In 1910, O.C. Hamilton purchased the Apartment Hotel and renamed it the Hamilton Hotel.

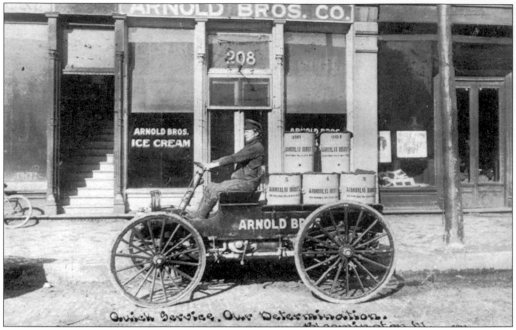

ARNOLD BROTHERS. Located at 208 East Front Street, it was the best-equipped ice cream factory in Bloomington with a daily capacity of 1,600 gallons. They had the only automobile in the city, which was used exclusively for delivering ice cream.

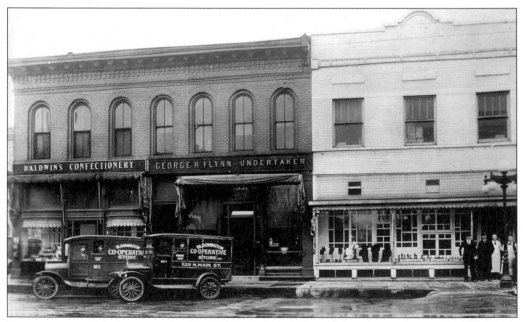

BLOOMINGTON BUSINESSES ON MAIN STREET. At left is Baldwin's Confectionery, 533 North Main Street. Lewis J. Baldwin was the owner and his residence was at 201 South Madison Street. At center is the office of George R. Flynn, Undertaker, 531 North Main Street. George R. Flynn was the owner and his residence was at 517 East Chestnut Street. At right is the Bloomington Co-Operative Store, 529 North Main Street.

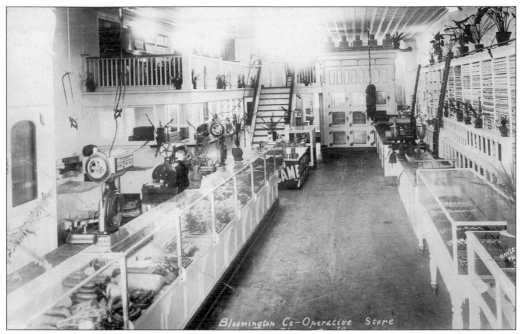

BLOOMINGTON CO-OPERATIVE STORE—INTERIOR VIEW. This co-operative was managed by L.J. Salch. A meat refrigeration area was located at the rear of the store, and the ladders on the right were used to reach merchandise on the upper shelves.

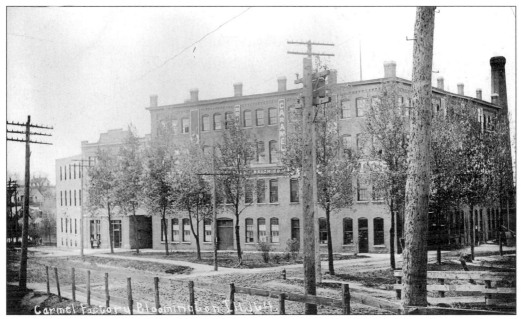

PAUL F. BEICH CARAMEL FACTORY. In 1893, Paul F. Beich began his candy business after purchasing the confectionery business of J.W. Gray & Company at 121 East Front Street. In January 1899, he purchased a factory from Lancaster Caramel Company at the corner of Front and Lumber Streets, which became the Paul F. Beich Company on January 1, 1905. In 1984, Beich's was sold to the Nestle Company.

13

BEICH'S CHOCOLATE GIRL. Portraits of pretty women were frequently used to advertise products. This one is a Christmas card advertising Beich's chocolate and is signed by the artist, Learned.

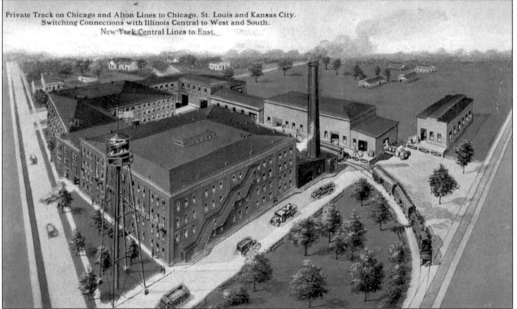

PAUL F. BEICH COMPANY PLANT. The company's location at the convergence of several railroad lines made sending chocolate all over the country much easier. The plant itself was expanded several times over a 15-year period with the last addition being added in 1923. The general offices were located at 109-111 South East Street.

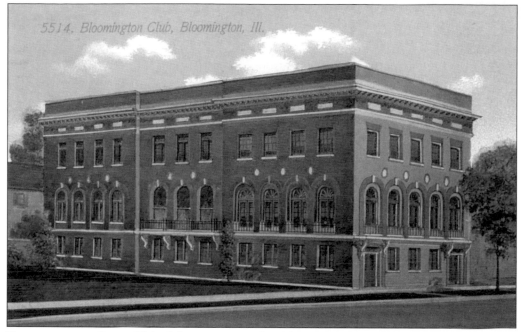

BLOOMINGTON CLUB. This club was organized and incorporated September, 1896, to promote the business interests of Bloomington. It was originally housed on the third floor of the Withers Library prior to its own building being erected at 210 East Washington Street.

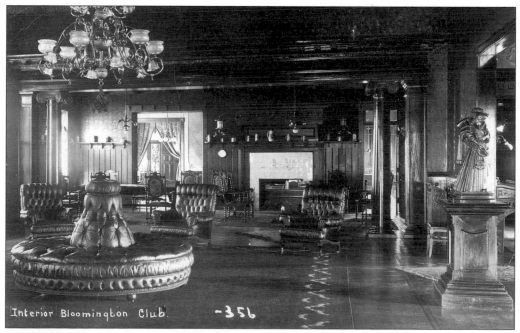

BLOOMINGTON CLUB—INTERIOR VIEW. Located just east of Withers Library, club membership was limited to 150. Note the elaborate lounge area with a fireplace.

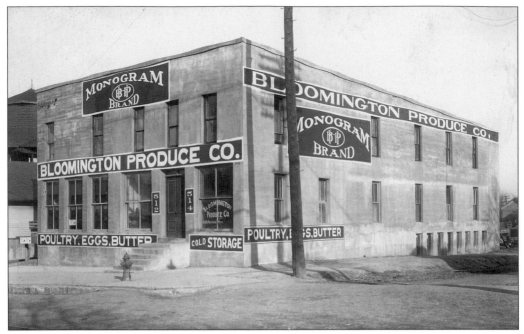

BLOOMINGTON PRODUCE COMPANY. Located at 512-514 South Main Street, this company was a wholesaler providing Monogram BP Brand, poultry, eggs, and butter to grocery stores. They also had cold storage capabilities. The officers of the company were as follows: Charles F.J. Agle, President; E.B Hawk, Vice President; H.B. Patton, Secretary and Manager; H.E. Gilberts, Treasurer.

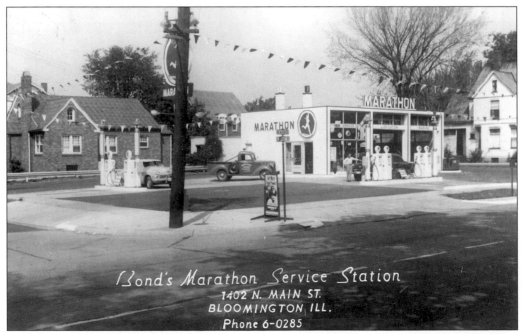

Bond's Marathon Service Station
1402 N. MAIN ST.
BLOOMINGTON, ILL.
Phone 6-0285

BOND'S MARATHON SERVICE STATION. Ralph Bond's well-kept pickup truck (parked next to station) was a welcome sight to motorists in need. Located at 1402 North Main Street, the station was managed by Ralph Bond, and John Peck was the Assistant Manager.

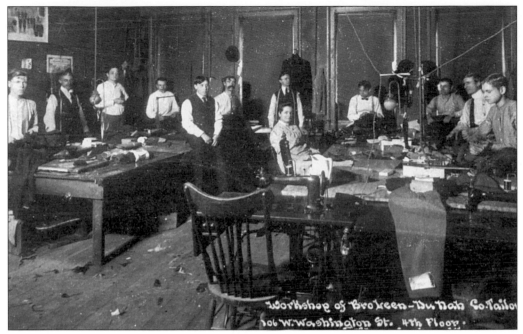

BRO LEEN DU NAH COMPANY TAILORS. The workshop was on the fourth floor at 106 1/2 West Washington Street. David A. Bro Leen came to Bloomington from Sweden in 1893 and began business in 1904. In 1907, George W. Du Nah joined the business.

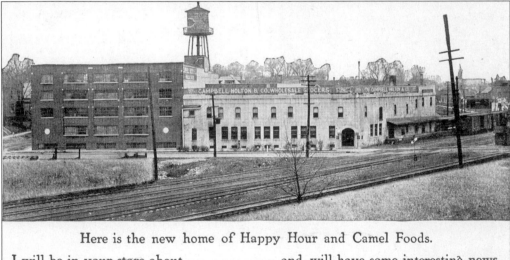

CAMPBELL HOLTON AND COMPANY. Organized in 1907, they were wholesale grocers and coffee roasters. 701-705 South Gridley Street was the "new home of Happy Hour and Camel Foods."

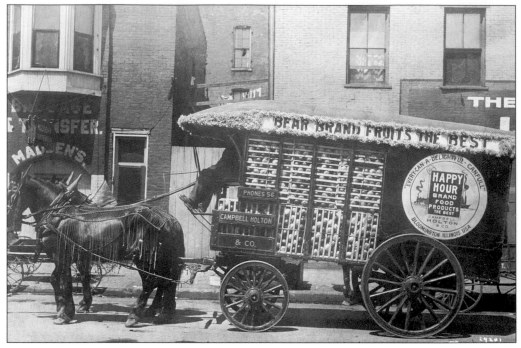

CAMPBELL HOLTON AND COMPANY. Pictured here is their delivery wagon. In the background is Madden's (Bus) Transfer Line and Horse Shoeing, which was at 105-107 South East Street.

A Gentle Reminder.

PEERLESS LAMPS
ARE JUST LIKE THIS.
BRIGHT, EFFICIENT AND ATTRACTIVE.
Sold by
GUY CARLTON,
Bloomington, Illinois.

GUY CARLTON. This card advertises everything electrical for home, office, factory, and automobile. His office was in the Hoblit building at 528 North Main Street.

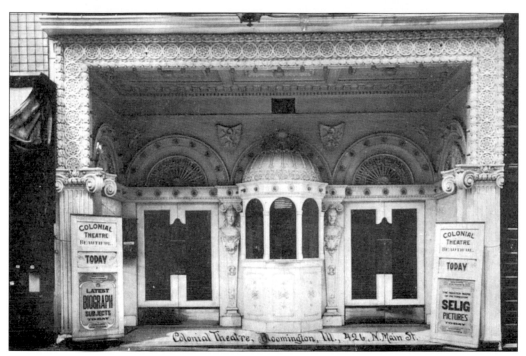

COLONIAL THEATER. Mr. Moore and Mr. Waldman owned this theater at 426 North Main Street. It opened in 1908 or 1909, and closed prior to 1915.

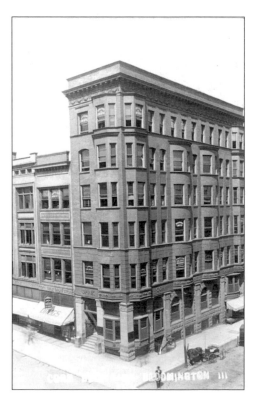

CORN BELT BANK. The building was located at 101 West Jefferson Street on the northwest corner of Jefferson and Main Streets. The Corn Belt Drug Store is next door to the west (left). The bank officers were John J. Pitts, President; O.P. Skaggs, Vice President; C.J. Moyer, Cashier; Claire McElhaney and H.E. Dumars, Assistant Cashiers.

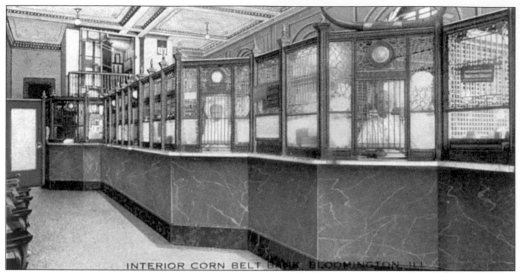

CORN BELT BANK—INTERIOR VIEW. This view shows two teller windows, a stairway to the balcony in rear of bank, the vault, and the lock boxes.

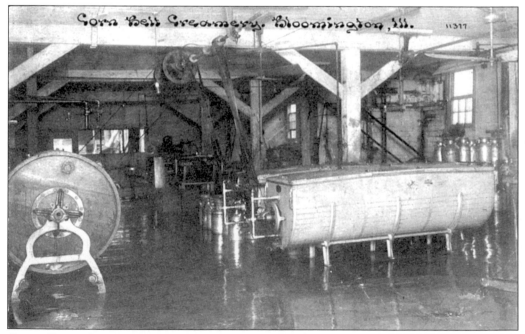

CORN BELT CREAMERY—INTERIOR VIEW. Located at 512-516 North Prairie Street, the creamery's advertising slogan was as follows: "Is made from pure cream from first class dairies in modern equipped creamery by skilled and experienced labor."

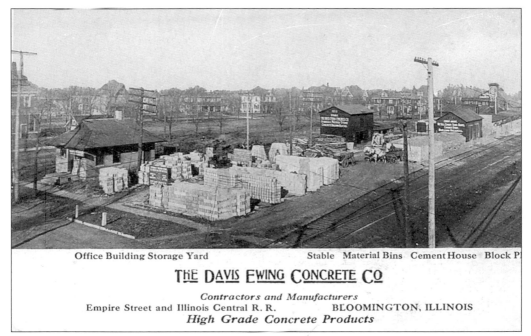

Office Building Storage Yard Stable Material Bins Cement House Block Pl

THE DAVIS EWING CONCRETE CO

Contractors and Manufacturers
Empire Street and Illinois Central R. R. BLOOMINGTON, ILLINOIS
High Grade Concrete Products

THE DAVIS EWING CONCRETE COMPANY. Contractors and manufacturers of high-grade concrete products located at 712 East Empire Street (at Empire Street and Illinois Central Railroad). Office building, storage yard, stable, material bins, cement house, and block plant are pictured.

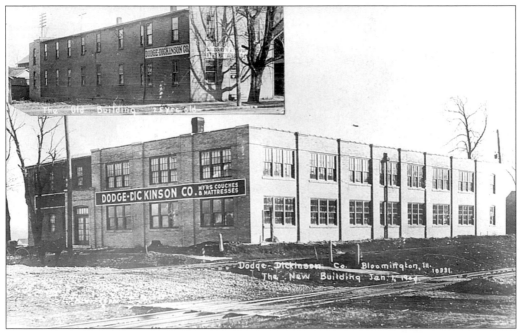

DODGE DICKINSON COMPANY. Incorporated in 1896, they were the manufacturers of couches and mattresses. The inset at the top shows the 25-year-old building. The "new" building, pictured at the bottom of card on January 1, 1909, was located at 816 East Grove Street.

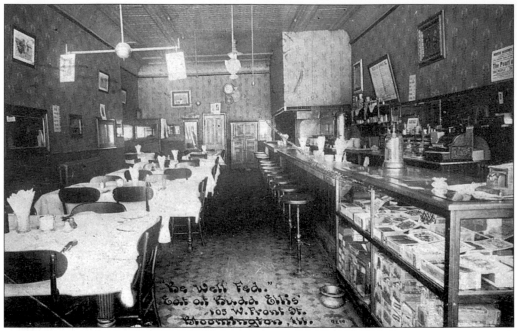

BUDD ELLIS CAFÉ. This establishment was a gathering place for friends to meet and have lunch or a cup of coffee. The café was located at 105 West Front Street and it's slogan was as follows: "Be well fed."

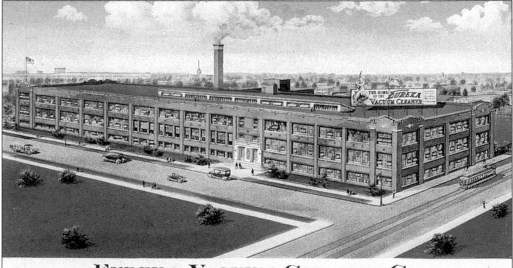

EUREKA VACUUM CLEANER CO.
FOREMOST MANUFACTURERS OF ELECTRIC VACUUM CLEANERS

EUREKA VACUUM CLEANER COMPANY. Located at 1201 East Bell Street, they were the "Foremost manufacturers of electric vacuum cleaners." In 1945, Detroit-based Eureka Company merged with Williams Oil-O-Matic to become the Eureka Williams Company.

A.B. Electrolux of Sweden purchased the company in 1974, and the name was changed to Eureka Company. In February 2000, this plant was closed and the jobs relocated to Texas and Mexico.

FIRST NATIONAL BANK. Erected in 1860, it was the oldest bank in the county and was located at 121 North Main Street (southeast corner of Main and Washington Streets). In 1892, capital and surpluses totaled $375,000. Officers of the bank were as follows: Wilbur M. Carter, President; Frank M. Rice, Vice President and Cashier; J.D. Templeton, Assistant Cashier.

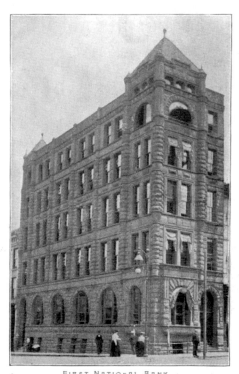

FIRST NATIONAL BANK
BLOOMINGTON, ILL.

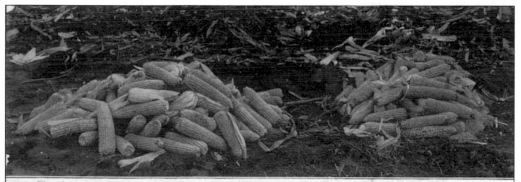

The pile on the right was raised from an ear of corn taken from the prize bushel at the National Corn Exposition 1907. The pile on the left from an ear taken from a bushel of our regular stock seed. Our corn produced at the rate of 77 bu. per acre. The prize corn at the rate of 62 bu. per acre.

Ten ears from the prize bushel and ten ears from our regular stock seed were planted side by side, under the same conditions and given the same cultivation. **Our ten ears** produced at the rate of 69.80 bu. per acre. The prize corn at 64.15 bu. per acre. At the same ratio a bushel of our corn would produce 33.9 bu. more than the bushel of prize corn. Doesn't this prove to you that our corn is bred to yield?

FUNK BROS. SEED CO.

DALLAS, TEXAS
NEW YORK, N. Y. 1744 **Bloomington, Ill.**

FUNK BROTHERS SEED COMPANY. Incorporated in 1901, it was located at 1402-1420 West Washington Street. The picture is a comparison of the yields from one ear of Funk's regular stock seed and one ear of the prize bushel at the National Corn Exposition in 1907. Advertising on back of card asks, "Can you be as certain of as high germination in any other corn?"

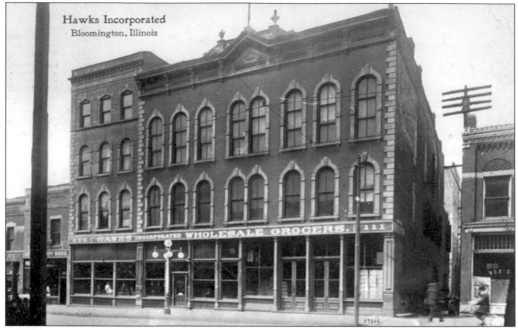

HAWKS INCORPORATED. These wholesale grocers were located at 111–115 South Main Street. The officers were E.P. Hawk, President; H.C. Hawk, Jr, Vice President; W.H. Cumming, Secretary.

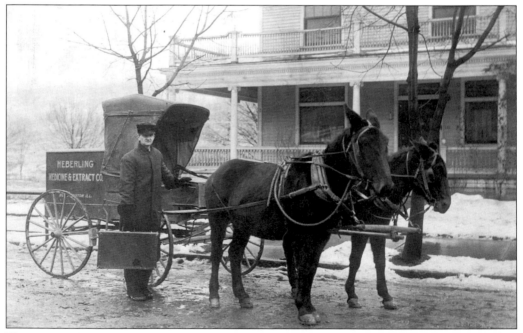

HEBERLING MEDICINES AND EXTRACT COMPANY. Incorporated in 1905, it was located at 217-223 East Douglas Street. The company was known in 25 states and employed 300 people. Here is a salesman standing beside his delivery wagon.

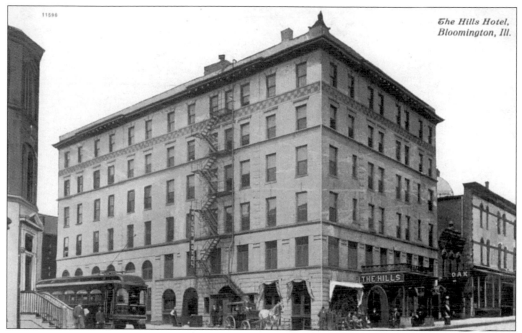

The Hills Hotel,
Bloomington, Ill.

HILLS HOTEL. Located at 219-221 West Washington Street, it was built in 1902 by Sam Arnold and contained 102 rooms. Eight months later, it was sold to Captain C.L. Hills. In 1908, another floor was added to the main building and three additional floors were added to the wing. This hotel later became the Hotel Tilden Hall.

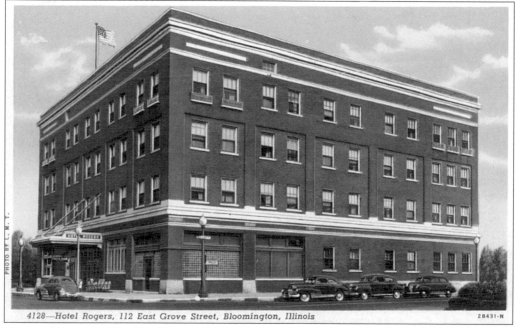

4128—Hotel Rogers, 112 East Grove Street, Bloomington, Illinois

HOTEL ROGERS. The hotel opened in 1926 in the rebuilt structure that had housed J.F. Humphreys and was located at 112 East Grove Street (northwest corner of Grove and East Streets). In 1969, the building was sold to the city.

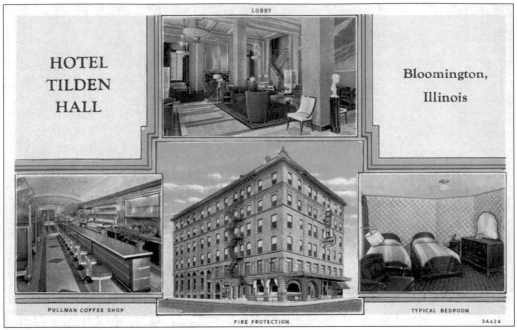

HOTEL
TILDEN
HALL

Bloomington,
Illinois

LOBBY

PULLMAN COFFEE SHOP

FIRE PROTECTION

TYPICAL BEDROOM

3A424

HOTEL TILDEN HALL. Located on the northeast corner of Washington and Madison Streets, it was previously known as the Arnold Hotel and Hills Hotel. At the time of its purchase in 1926, it was called the Arlington Hotel. Following renovation, on September 2, 1933, it was renamed the Hotel Tilden Hall and opened for public inspection with a dinner dance and floor show. In 1961, it was sold to People's Bank for use as a parking lot.

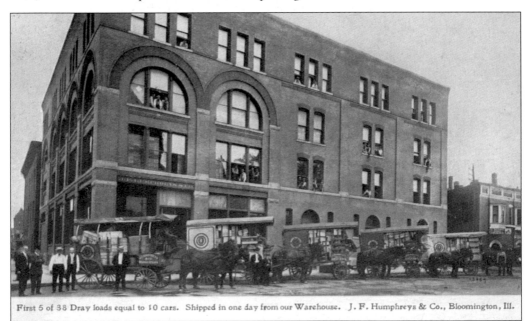

First 5 of 38 Dray loads equal to 10 cars. Shipped in one day from our Warehouse. J. F. Humphreys & Co., Bloomington, Ill.

J.F. HUMPHREYS AND COMPANY. Home of the Wedding Ring Brand, and providers of a "full line of good things to eat," it was on the northwest corner of Grove and East Streets. Picture shows the first 5 drays (wagons) of the 38 that were shipped out that day from their warehouse.

HUNGARIAN ROLLER MILL COMPANY.
Located at 1006 West Jefferson Street, it was built in 1882. The company produced winter and spring wheat flour and had a capacity of 350 barrels a day.

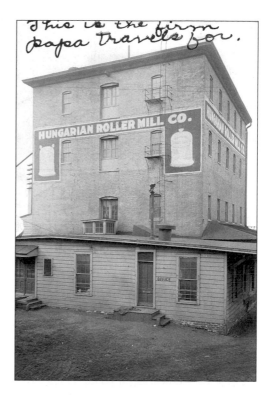

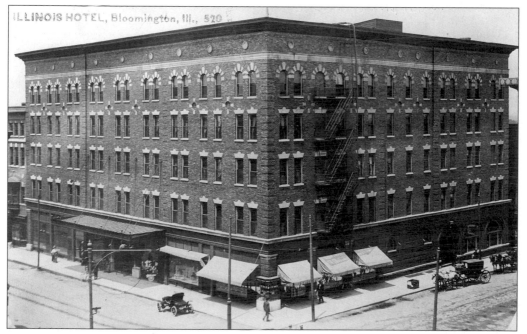

ILLINOIS HOTEL. Built in 1900 following the destruction of much of downtown in the fire of June 1900, it became one of the first fireproof buildings. It was originally four stories high, but in the late 1920s, two additional floors were added. The hotel was located at 201–213 West Jefferson Street.

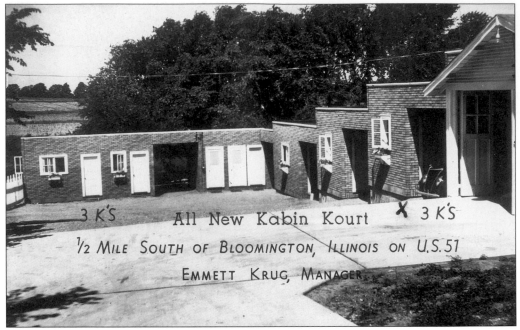

3K's cabin Kourt
3K'S All New Kabin Kourt X 3K'S
½ MILE SOUTH OF BLOOMINGTON, ILLINOIS ON U.S.51
EMMETT KRUG, MANAGER

3K's Motel (Krug's Kabin Kourt). Located one-half mile south of U.S. 51, it featured private baths, garages, oil heat, children's playground, and picnic facilities. Both modern cabins and tourist rooms were available. Emmett Krug was the manager.

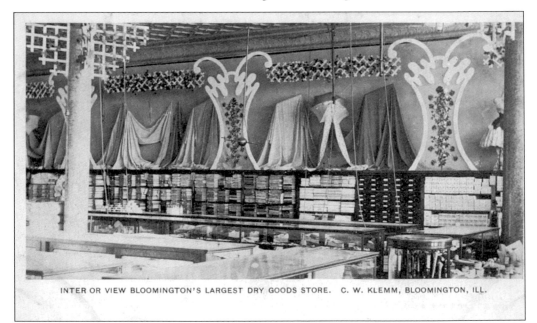

INTER OR VIEW BLOOMINGTON'S LARGEST DRY GOODS STORE. C. W. KLEMM, BLOOMINGTON, ILL.

C.W. Klemm—Interior View. This business opened in 1873, two doors east of the corner of Jefferson and Center Streets at 105-109 West Jefferson Street. The building was destroyed in the great fire of 1900 and was rebuilt. It was again destroyed by fire in 1909 and rebuilt. Klemm's celebrated 50 years in business on November 7, 1923. The store eventually closed in 1981, but the building remains.

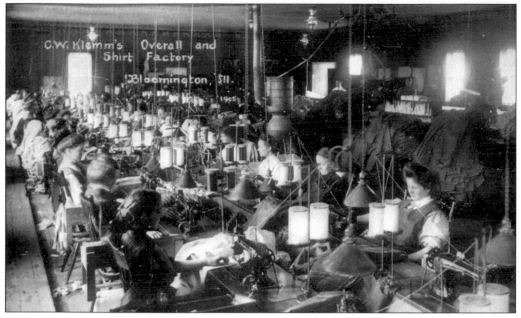

C.W. KLEMM'S OVERALL AND SHIRT FACTORY. In 1873, C.W. Klemm came to Bloomington and opened for business in the 300 block of North Center Street. (This building would later be known as the Monroe Building.) In 1964, Klemm sold his business to Virtin Brothers, a Michigan firm.

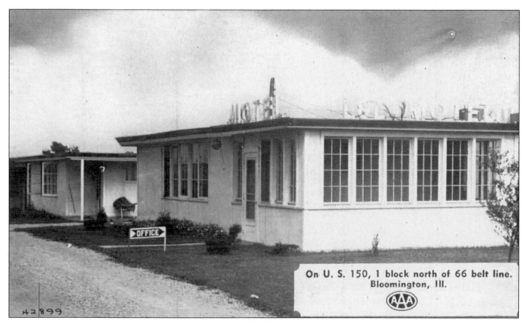

L AND L MOTEL. Located on U.S. 51, one block north of Route 66 belt line, it featured clean rooms and private baths. It was located away from highway noise and restaurants were nearby.

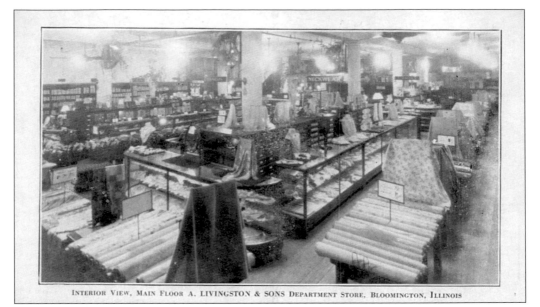

INTERIOR VIEW, MAIN FLOOR A. LIVINGSTON & SONS DEPARTMENT STORE, BLOOMINGTON, ILLINOIS

A. LIVINGSTON AND SONS DEPARTMENT STORE—INTERIOR VIEW, MAIN FLOOR. Organized in 1866, it was located on the south side of the square at 110-114 West Washington Street. The store features included a balcony, elevator, and air vents between the outer and inner doors that blew warm or cool air depending on the time of the year. The store closed in January 1979.

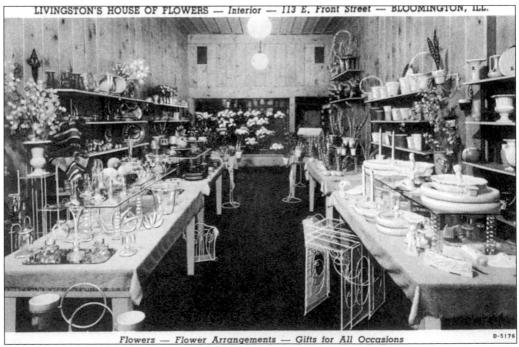

LIVINGSTON'S HOUSE OF FLOWERS — Interior — 113 E. Front Street — BLOOMINGTON, ILL.

Flowers — Flower Arrangements — Gifts for All Occasions D-5176

LIVINGSTON'S HOUSE OF FLOWERS—INTERIOR VIEW. Store contained gifts for all occasions including flowers, flower arrangements, and vases and containers for decorating. The business was located at 113 East Front Street from 1938 until 1943.

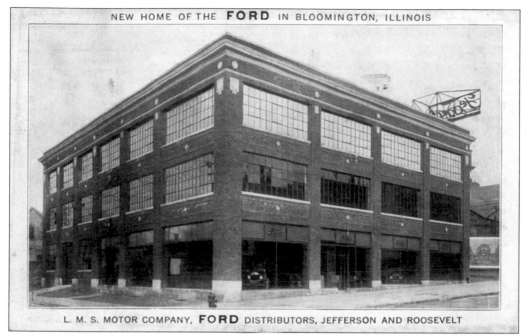

L. M. S. MOTOR COMPANY, **FORD** DISTRIBUTORS, JEFFERSON AND ROOSEVELT

L.M.S. MOTOR COMPANY—FORD DISTRIBUTORS. Located at the corner of Jefferson and Roosevelt Streets, it was the "new home of the Ford in Bloomington, Illinois." The message on the back of the card, dated 1916, refers to the price of gas being 18 1/2¢ per gallon.

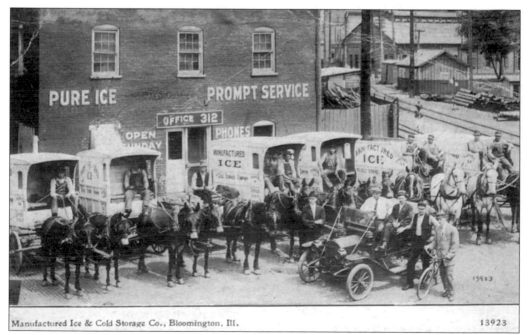

Manufactured Ice & Cold Storage Co., Bloomington, Ill. 13923

MANUFACTURED ICE AND COLD STORAGE. Located at 308-312 South Lee Street, they made, stored, and delivered ice as needed. Picture shows their horse-drawn delivery wagons.

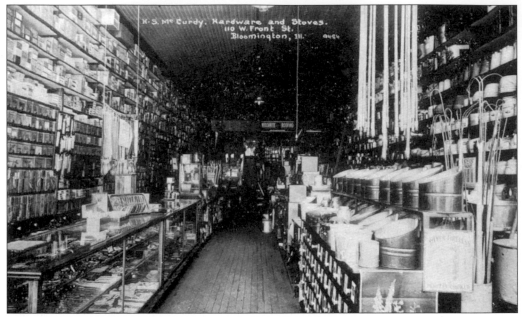

H.S. McCurdy Hardware and Stoves. They were known for selling American field and hog fencing ("Once up, stays up"), cream separators, and Wonder churns. The store was located at 110 West Front Street. In 1926, the stock was purchased by the hardware firm of Gordon H. Read and Brothers.

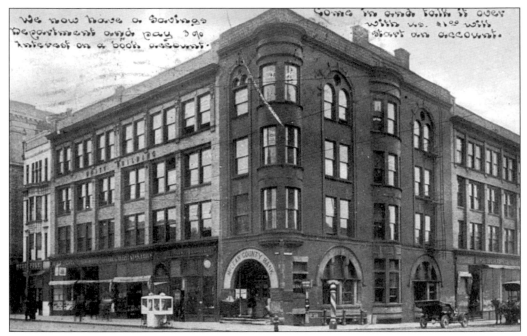

McLean County Bank. Founded in 1853 by Asahel Gridley, it was located at 201 North Main Street (northeast corner of Main and Washington Streets). The assets and resources totaled $673,461.41. According to the card, $1 would start an account, and they paid three percent interest. (Note the popcorn wagon outside the entrance.)

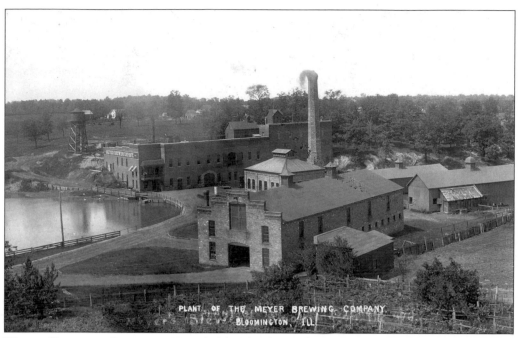

MEYER BREWING COMPANY. Founded in 1862 by Anthony Meyer and F.X. Wochner, it was located at 1625 South Main Street. Today, this location is the home of Highland Park Golf Course; the Pro Shop building was also part of the Meyer Brewing Company.

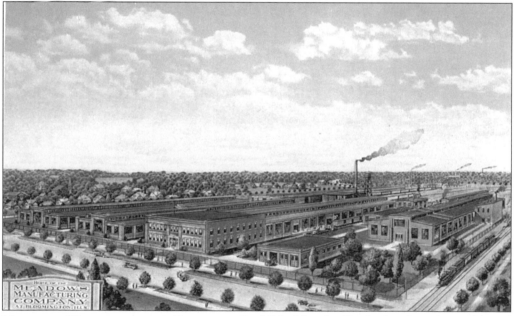

MEADOWS MANUFACTURING COMPANY. Established by the Rocke brothers, it was located near the corner of McClun and Bell Streets. The factory began in Meadows, Illinois, (just east of Lexington) as a small shop for making grain elevators. It was enlarged and then eventually moved to Pontiac, Illinois. Later, the company moved to Bloomington, Illinois, and in 1923, they were manufacturing both grain elevators and washing machines.

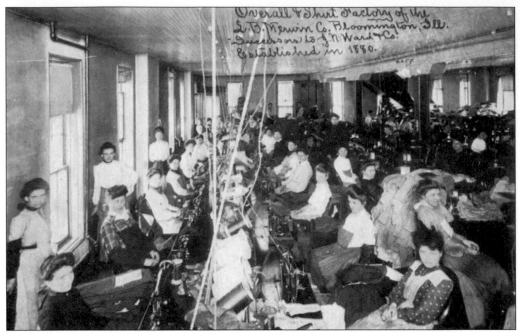

L.B. Merwin—Overall and Shirt Factory. Successors to J.N. Ward and Company, which was established in 1880, the factory was located at 509-513 North East Street.

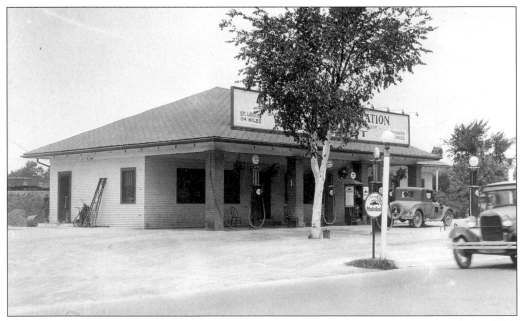

Miller's Service Station. Located at 1201 South Main Street in Normal, Illinois, this service station also served as the bus depot. According to the sign on the building, it was 174 miles to St. Louis and 135 miles to Chicago. Gas, oil, soft drinks, lunch, and dinner were also available.

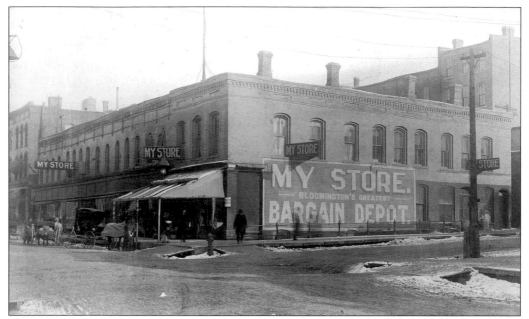

MY STORE "BLOOMINGTON'S GREATEST BARGAIN DEPOT." This store was on the northeast corner of South Center and West Grove Streets. On July 1, 1899, the firm of Bachrach and Mandel dissolved their partnership. Mr. Oscar Mandel purchased and conducted the business and Mr. John Bachrach retired.

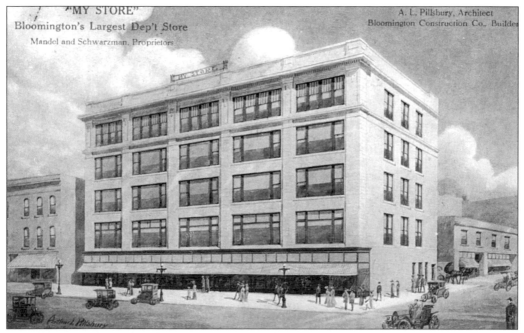

MY STORE "BLOOMINGTON'S LARGEST DEPARTMENT STORE." Designed by the architect, A.L. Pillsbury, and built by the Bloomington Construction Company, the store was located at 114-116 West Front Street and 108-120 South Center Street. The store closed on April 19, 1931.

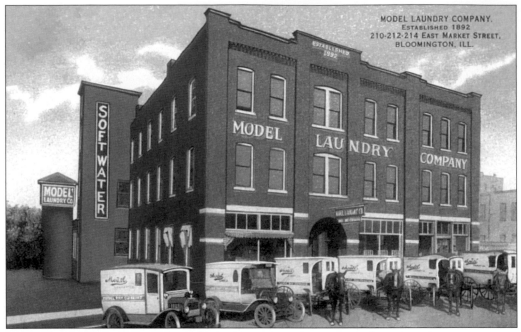

MODEL LAUNDRY COMPANY. Established in 1892 and incorporated in 1894, this company was located at 210–214 East Market Street. The delivery wagons displayed are a mix of horse-drawn and motorized.

M.J. NORMILE SALOON. Located at 601 West Market Street, this saloon served Buck Beer. The people pictured here are those also pictured in front of the Green Tree Bottling Works on the following page. Later, this building was the home of Boylan's Ice Cream.

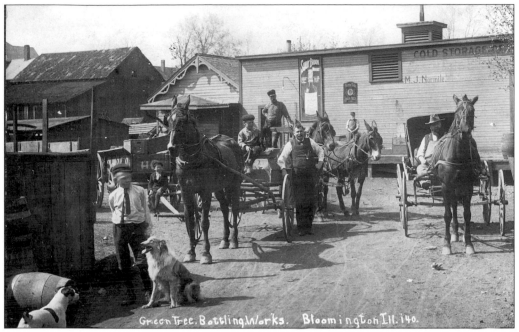

GREEN TREE BOTTLING WORKS. Housed in the back part of the M.J. Normile Saloon (601 West Market Street), they were known for bottling Sunny Brook Whiskey and Green Tree Lager Beer.

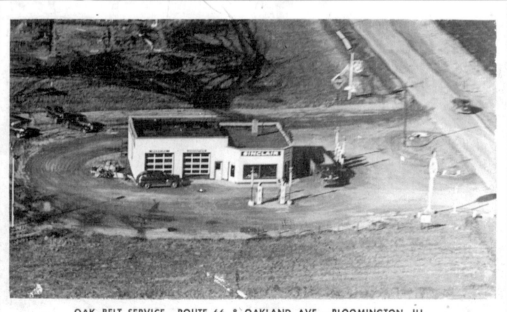

OAK BELT SERVICE—ROUTE 66 & OAKLAND AVE.—BLOOMINGTON, ILL.

OAK BELT SERVICE. A Sinclair station that was located on the southwest corner of Route 66 and East Oakland Avenue. The station sold gas, oil, Goodyear tires, and batteries, and considered greasing and washing their specialties. They were open from 7 a.m. to 9 p.m. and had "clean restrooms."

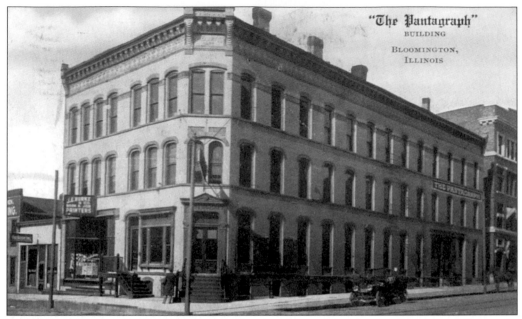

THE PANTAGRAPH. On November 1, 1875, *The Pantagraph* occupied their new building at the northwest corner of Washington and Madison Streets. The building was designed by H.A. Miner, Architect. *The Pantagraph* is now Bloomington's only daily newspaper with a circulation of over 47,000.

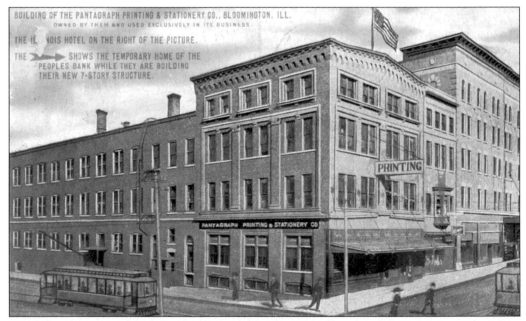

THE PANTAGRAPH PRINTING AND STATIONERY COMPANY. Incorporated in 1889, it was located at 217-219 West Jefferson Street. The picture also shows the Illinois Hotel (to the right). The arrow points to the temporary home of Peoples Bank while construction of their new seven-story building was under way. The new building was built on the same site as the old one, which was on the southwest corner of Center and Washington Streets.

PEOPLE'S BANK. Chartered in 1869, the bank was located at 120 North Center Street (southwest corner of Center and Washington Streets). George W. Parke was the first president from 1869–1875. In 1909, a seven-story building was erected on the same site. Their temporary location was on West Jefferson Street between the Illinois Hotel and the Pantagraph Printing and Stationery Company.

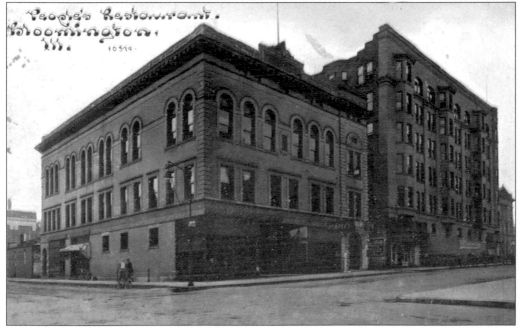

PEOPLE'S RESTAURANT. This popular gathering place and great restaurant located on the southwest corner of Jefferson and East Streets at 115 East Jefferson Street closed in the early 1930s.

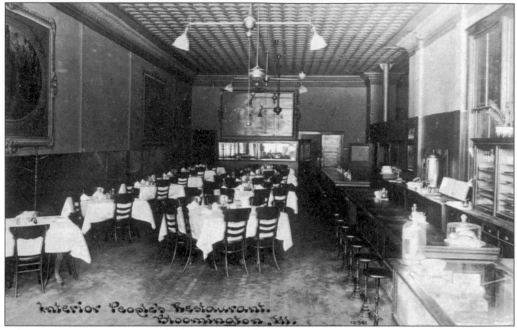

PEOPLE'S RESTAURANT—INTERIOR VIEW. Because the downtown business people frequented this restaurant, it was a busy place at lunchtime.

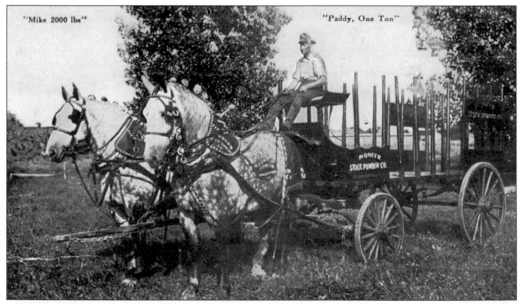

PIONEER STOCK POWDER COMPANY. Offices were located on East Front Street (just east of the Central Fire Station) and the factory was at 1702 West Washington Street. The company manufactured a feed supplement for horses that made their coats smooth and shiny. The picture is of one of the company's horse-drawn delivery wagons.

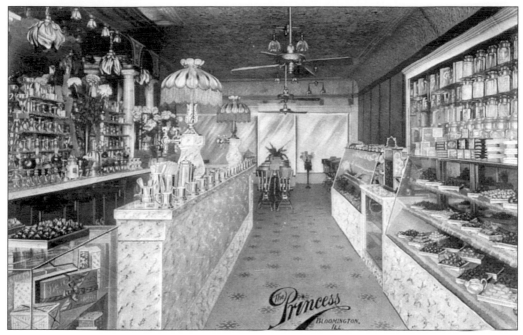

THE PRINCESS (CONFECTIONERY STORE). Located at 106 West Washington Street, it was owned by C.D. Phillos who also owned Phillos' Candy Store at 108 North Center Street.

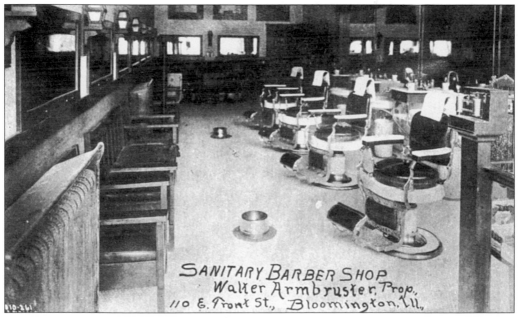

SANITARY BARBER SHOP. Four up-to-date chairs await the next customer. Note the spittoons in the center of the shop. The shop was located at 110 East Front Street from 1902 to 1934 and was owned by Walter Armbruster.

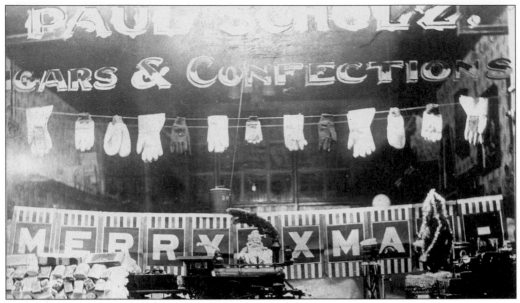

PAUL SCHOLZ CIGARS AND CONFECTIONS. Located at 1018 West Washington Street on the southwest corner of Washington Street and Morris Avenue, the store opened for business in 1898 or 1899 and closed sometime between 1905 and 1907.

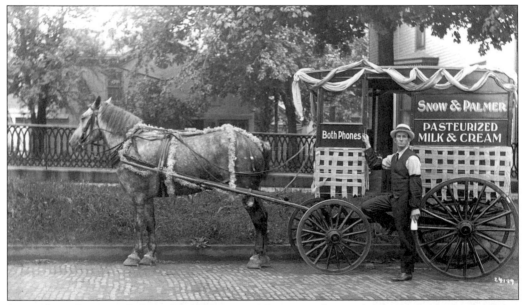

SNOW AND PALMER DAIRY. In 1897, two McLean area farmers became partners in the Snow and Palmer Dairy at 602 West Jefferson Street. They later moved to the 500 block of West Washington Street. Pictured is a horse drawn delivery wagon decorated for the Manufacturers Parade in 1911. In 1929, Snow and Palmer Dairy became part of Beatrice Foods and home delivery was discontinued in 1977.

STATE FARM MUTUAL INSURANCE COMPANY. On June 7, 1922, George J. Mecherle sold his first auto insurance policy to Henry Stubblefield. The company was organized in 1923, and began selling policies in other states in 1925. In 1929, this eight-story building was erected on the northwest corner of Washington and East Streets. Today it is referred to as the "Downtown Building."

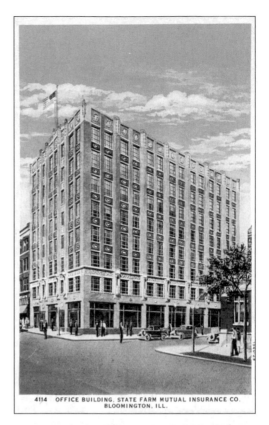

4114 OFFICE BUILDING, STATE FARM MUTUAL INSURANCE CO.
BLOOMINGTON, ILL.

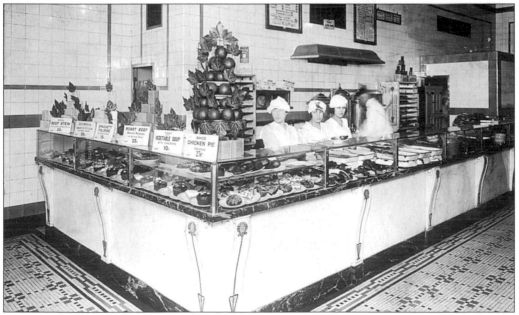

THOMPSON CAFETERIA. Located at 208 North Center Street, it opened in 1917. Pictured from left to right are the following: Dolly Meredith Mohr, Florence Halfley, and Miss Lilianthal. For a sign of the times, note the prices of the various entrees. The cafeteria closed in 1955.

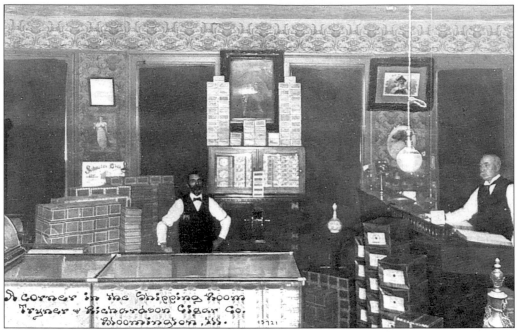

TRYNER AND RICHARDSON CIGAR COMPANY. In 1879, the firm of Tryner and Richardson began cigar manufacturing at 116 South Main Street. The building was three stories high and had a warehouse in the rear. The picture is a view of their shipping room at 106 1/2 North Main Street as it appeared in 1911. The business ceased operations between 1911 and 1915.

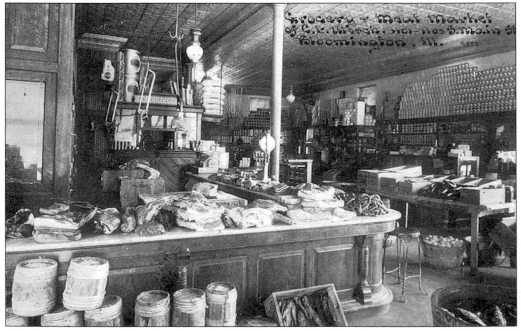

C.L. UTESCH GROCERY AND MEAT MARKET. The original market was located at 1101-1103 South Main Street. In 1910, Utesch and Syfert went into business together and opened a market at 428-430 South Main Street.

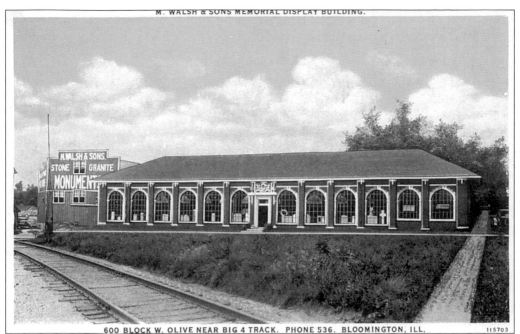

600 BLOCK W. OLIVE NEAR BIG 4 TRACK. PHONE 536. BLOOMINGTON, ILL. 115703

M. WALSH AND SONS MEMORIAL DISPLAY BUILDING. Located at 620 West Olive Street, they were known for having the "largest and most complete new stock of granite memorials in Central Illinois at the lowest prices." Don Owen Tire Service, Inc. is at this site today.

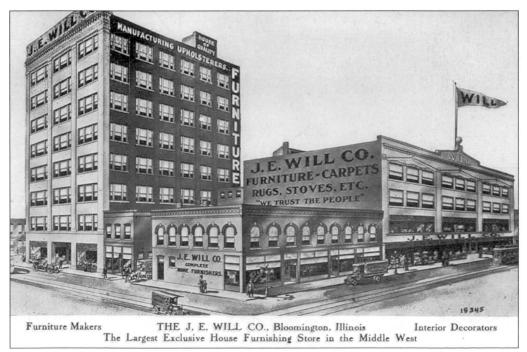

Furniture Makers THE J. E. WILL CO., Bloomington, Illinois Interior Decorators
The Largest Exclusive House Furnishing Store in the Middle West

THE J.E. WILL COMPANY. Home furnishing store that carried everything needed for a well-furnished home. The company was located at 508–512 North Main Street.

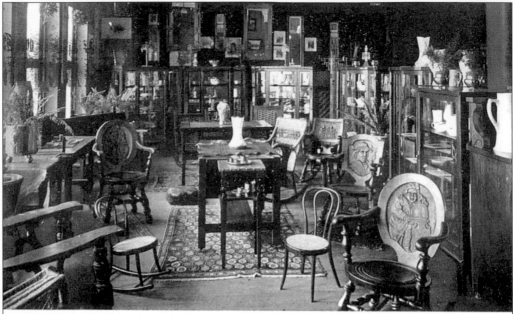

ART DEPARTMENT The J. E. WILL COMPANY, Manufacturing Upholsterers
Furniture, Rugs and Draperies 508-10-12 N. Main St., Bloomington, Ill. The White Front Furniture Shop

THE J.E. WILL COMPANY—INTERIOR VIEW. The Art Department displays a variety of furniture and decorating accessories.

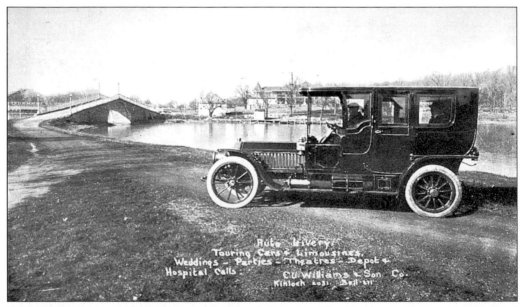

C.U. WILLIAMS AND SON COMPANY—AUTO LIVERY. The livery provided touring cars and limousines for hire. People could hire the cars for weddings, parties, hospital calls, or any other event where transportation was required. Miller Park's bridge and pavilion are in the background.

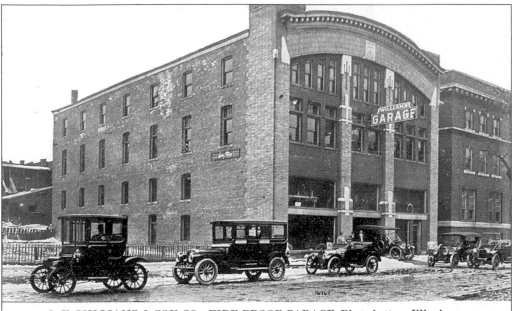

C. U. WILLIAMS & SON CO., FIRE PROOF GARAGE. Bloomington, Illinois

| Chalmers | Moon | Studebaker | Stearns Knight | Woods Electric |

C.U. WILLIAMS AND SON COMPANY "FIRE PROOF GARAGE." The company sold various models of automobiles, including Chalmers, Moon, Studebaker, Stearns Knight, and Woods Electric at 203 East Washington Street. In 1916, Williams built a six-story building next to the garage to expand his business and house the Castle Theater.

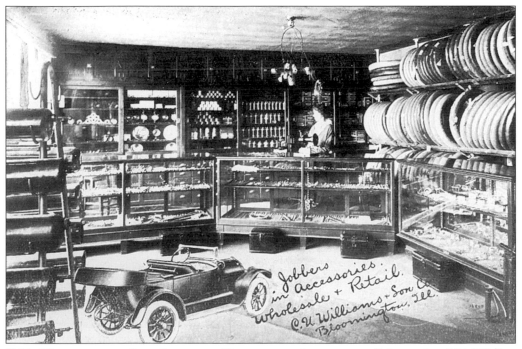

C.U. WILLIAMS AND SON COMPANY "JOBBERS IN ACCESSORIES." Located at 207–209 East Washington Street, the company provided everything needed to keep automobiles running.

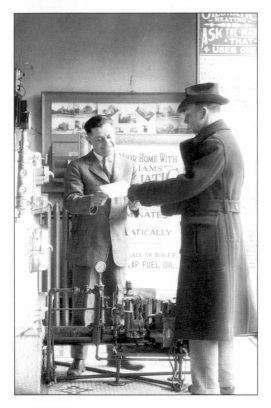

C.U. WILLIAMS AND SON COMPANY—OIL-O-MATIC. In 1925, Williams Oil-O-Matic was first used to heat the C.U. Williams Garage and the adjoining Castle Theater. Note the list of satisfied customers on the wall, which includes some prominent area citizens.

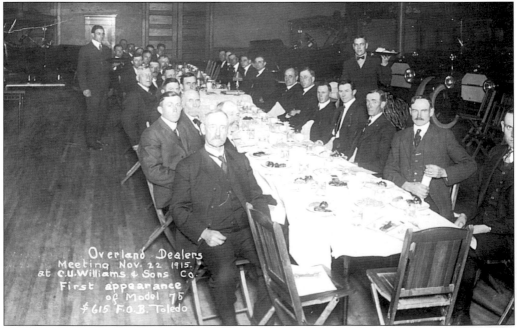

C.U. WILLIAMS AND SON COMPANY—OVERLAND DEALERS MEETING. The meeting occurred on November 22, 1915, and was the first appearance of Overland's Model 75 automobile. The cost was $615.

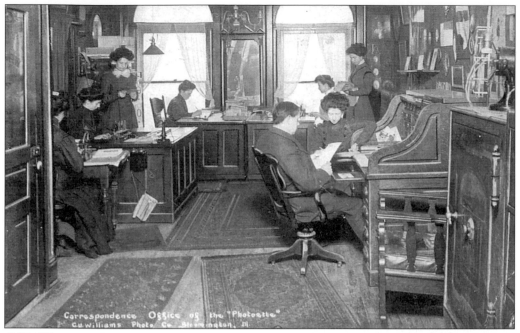

Correspondence Office of the "Photoette"
C.U.Williams Photo Co., Bloomington, Ill.

C.U. WILLIAMS PHOTO COMPANY—SOUTH SIDE OF SQUARE. Pictured here is the interior of the correspondence office of the *Photoette*. It is also an advertising card, to be returned to C.U. Williams, to obtain additional information regarding the purchase of local view cards.

Fadeless Photos Dear Friend; Bloomington, Ill. 11/27/06.

Did you receive the certificate we mailed you? It will save you $2.00 and help decide on 12 Xmas gifts.

Photos make the best Christmas Presents.

You cannot afford to pass $5.00 pictures at $3.00. Large one included. Better style work cannot be had.

Bring your certificate, if lost, bring this card.

Photo of your Court House

C.U. Williams, South Side Court House Photographer.

C.U. WILLIAMS, PHOTOGRAPHER. The courthouse is pictured on this advertising card for the "fadeless photo." Advertising suggests that photos make the best Christmas presents and offers the holder of the card a special price on photographs.

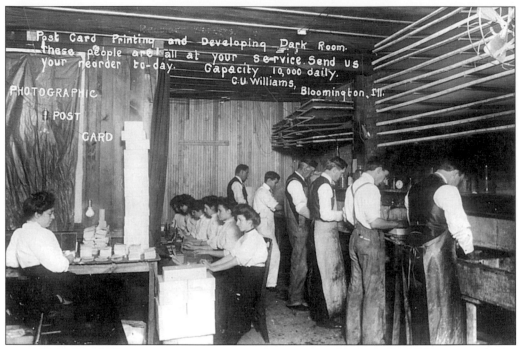

C.U. WILLIAMS POST CARD PRINTING AND DEVELOPING DARK ROOM. The picture depicts studio employees working and ready to serve customers. The production volume was 10,000 postcards daily.

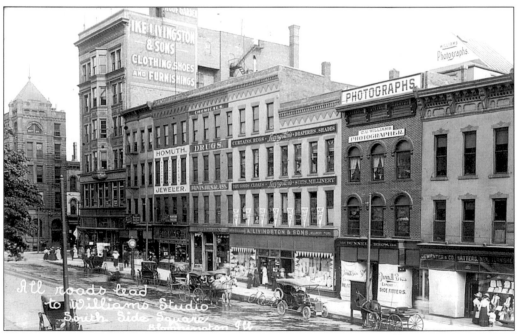

C.U. WILLIAMS STUDIO. "All roads lead to Williams Studio." This advertising card shows the Williams Studio, which was located in the 100 block of West Washington Street, on the south side of the square. The back of the card offers the holder a special price on photographs.

Three
BUILDINGS

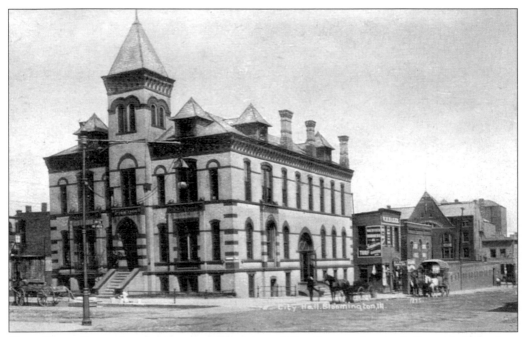

CITY HALL. Located at the corner of Monroe and East Streets, the city hall was dedicated on January 7, 1898. The building was 3 stories high with 10,000 square feet of floor space. The east side entrance was used by the police department. A valuable improvement was a vault, built from the basement up, and having access from all floors via doors with combination locks.

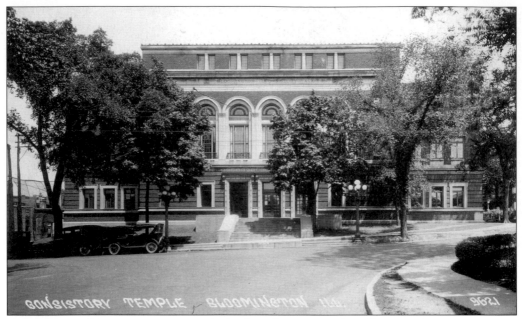

CONSISTORY TEMPLE. In May 1918, land at the corner of Mulberry and East Streets was purchased. R.G. Schmid and Company was the architect and Simmons-Dick Company was the contractor. The total cost, including land, construction, and furnishings, was $586,000. This building is also known as the Scottish Rite Temple.

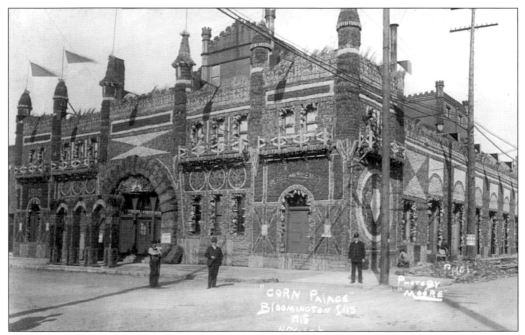

CORN PALACE. Normally known as the Coliseum, for a couple of weeks out of the year, it was decorated with corn and became the Corn Palace. Located at 401–403 West Front Street, it had yearly displays from 1903–1916 and the cost of admission was ¢10. In 1938, it housed a bowling center and in 1961, it was razed to make room for a used car lot.

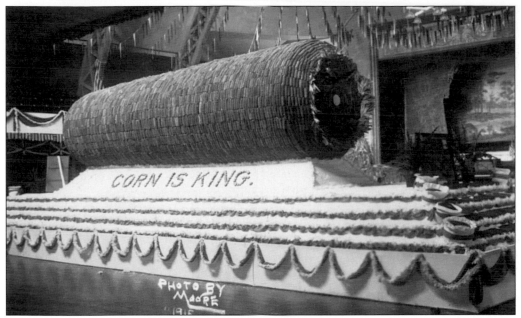

CORN PALACE. Display shows large ear of corn that was housed in a building that was 120 feet by 160 feet and was entirely covered with corn, oats, alfalfa, and grasses. This building was visited by thousands of people. Daily concerts and high-class vaudeville, together with agricultural lectures, formed the program from October 18-28, 1915.

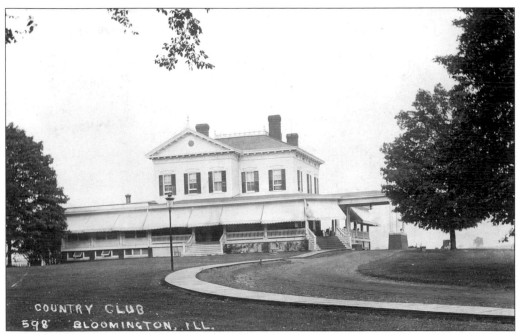

COUNTRY CLUB. Located at 605 Towanda Avenue, the building was dedicated in 1903. It was the former home of George P. Davis known as "Bellemont." (George was the son of David Davis, a good friend of Abraham Lincoln.) The building was destroyed by fire on May 21, 1929, and was rebuilt.

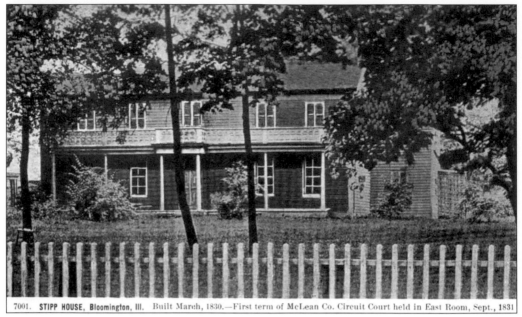

7001. **STIPP HOUSE, Bloomington, Ill.** Built March, 1830.—First term of McLean Co. Circuit Court held in East Room, Sept., 1831

COURTHOUSE. Located on the southeast corner of Grove and East Streets, it was built in March of 1830, and was known as the "Stipp House." The first term of the McLean County Circuit Court was held in the east room during September of 1831. It also housed the first store and first post office.

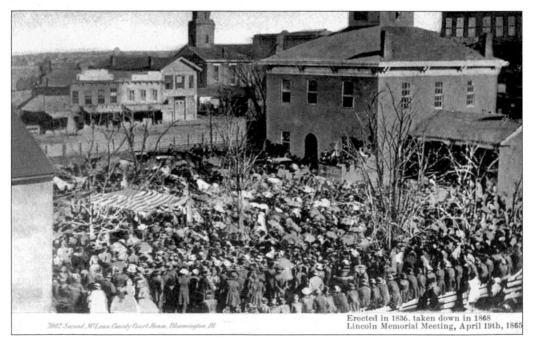

7002 Second McLean County Court House, Bloomington, Ill.

Erected in 1836. taken down in 1868
Lincoln Memorial Meeting, April 19th, 1865

COURTHOUSE. The second McLean County Courthouse was erected in 1836. A Lincoln Memorial meeting was held here on April 19, 1865. In 1868, construction of the third courthouse began and the second one was razed. The third courthouse was burned in the fire of 1900 and the fourth courthouse was completed in 1903.

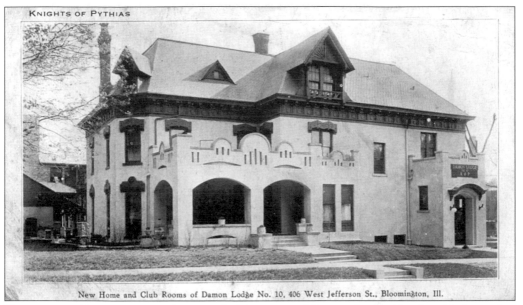

New Home and Club Rooms of Damon Lodge No. 10, 406 West Jefferson St., Bloomington, Ill.

KNIGHTS OF PYTHIAS. New home and club rooms of Damon Lodge Number 10, located at 406 West Jefferson Street. Captain Gleon Hills sold the home to the Pythian order on January 10, 1922 for $20,000.

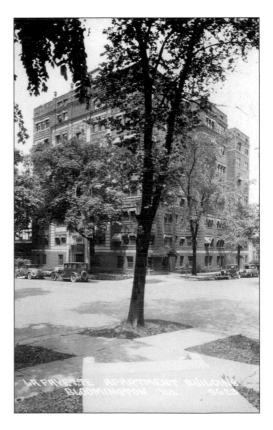

LaFAYETTE APARTMENT BUILDING. Built in 1919 by the LaFayette Apartment Company with a Georgian style of architecture, it is located at 410-412 East Washington Street. Some of the features were electric elevators and vacuum cleaner pipes to individual apartments. On top of the nine-story building was a solarium or winter garden.

55

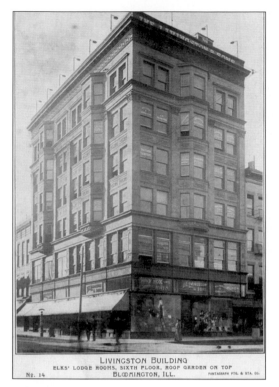

LIVINGSTON BUILDING
ELKS' LODGE ROOMS, SIXTH FLOOR, ROOF GARDEN ON TOP
No. 14 BLOOMINGTON, ILL. PANTAGRAPH PTG. & STA. CO.

LIVINGSTON BUILDING. Ike Livingston and Sons owned this six-story building located on the southwest corner of Main and Washington Streets. The building contained the Elks Lodge and a rooftop garden.

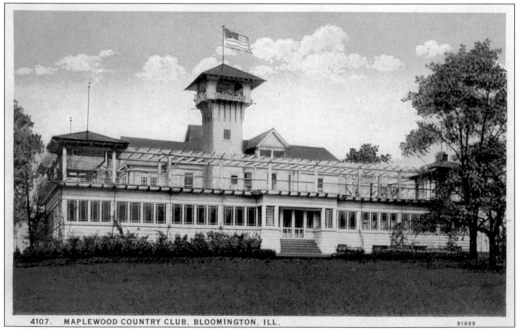

4107. MAPLEWOOD COUNTRY CLUB, BLOOMINGTON, ILL. 91688

MAPLEWOOD COUNTRY CLUB. Located at 1104 South Linden Street, Normal, it was the homestead of W.A. Watson. The club acquired the home and improved it into a modern country club house, and the large grounds were converted into a golf course. Most of the club members were from Normal, with only a few from Bloomington.

56

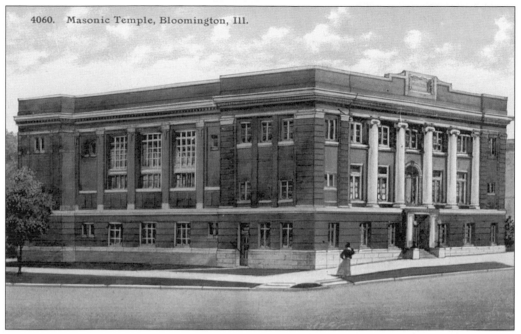

4060. Masonic Temple, Bloomington, Ill.

MASONIC TEMPLE. On April 25, 1911, the cornerstone was laid at 302-304 East Jefferson Street. The dedication ceremony was held on Tuesday, April 25, 1912 with additional ceremonies held on Wednesday and Thursday. The building still stands today.

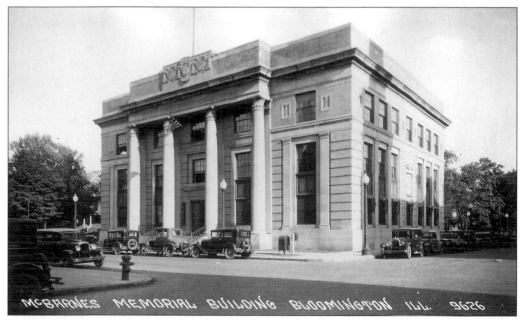

McBARNES MEMORIAL BUILDING BLOOMINGTON ILL. 9626

McBARNES MEMORIAL BUILDING. In 1921, Mr. and Mrs. John McBarnes gave a monetary gift to erect a memorial to McLean County men who served in World War I. On May 27, 1922, the cornerstone was laid at 201-205 East Grove Street and the dedication was on April 30, 1923. The building was built on the site formerly occupied by the Stipp House, which was McLean County's first courthouse.

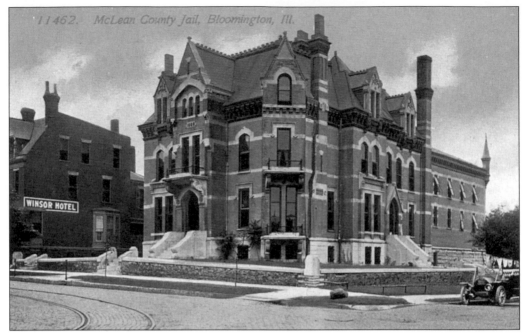

McLean County Jail. Between 1832 and 1882, there were four jails and they alternated between the courthouse square and the corner of Center and Market Streets. The building costs ranged from $331 to $13,150. In 1882, this jail was built at the corner of Madison and Monroe Streets at a cost of $72,000.

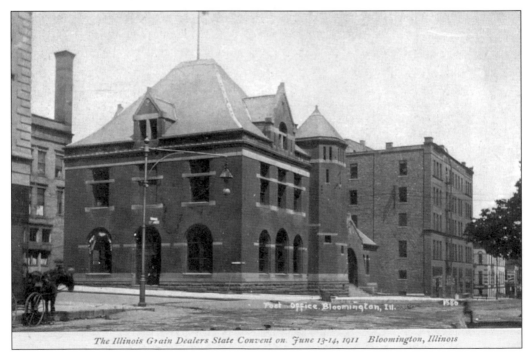

Post Office. Erected in 1896 at the corner of Jefferson and East Streets, the post office on this card advertises the Illinois Grain Dealers State Convention, June 13-14, 1911.

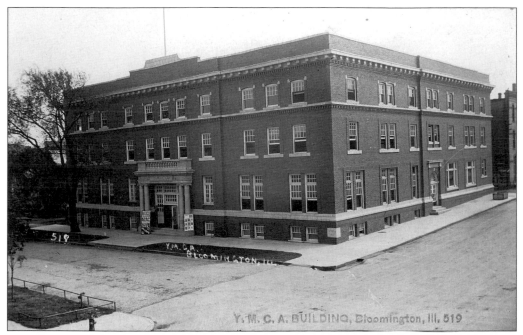

Y.M.C.A. BUILDING. The building was erected in 1907 at 201-205 East Washington Street. Charles Fairbanks, Vice President of the United States, spoke at the dedication ceremony on September 23, 1907. The new Y.M.C.A. was built at 602 South Main Street and opened August 1, 1972. After the opening, the former building was razed.

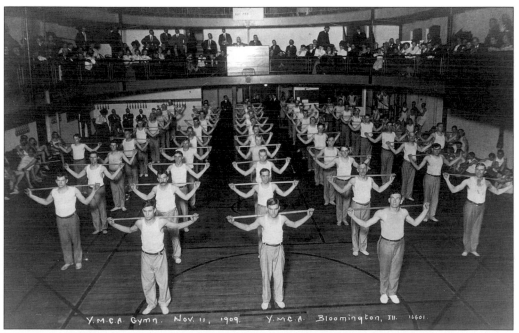

Y.M.C.A. BUILDING. On November 11, 1909, the physical education department hosted an exhibition attended by 400-500 people. Seventy-five men and one hundred boys took part in demonstrating dumbbell exercises, gymnastic dancing, and a wand drill.

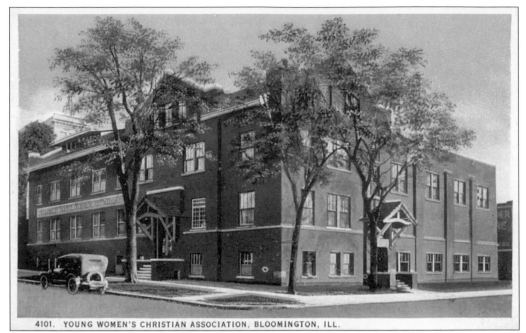

4101. YOUNG WOMEN'S CHRISTIAN ASSOCIATION, BLOOMINGTON, ILL.

Y.W.C.A. BUILDING. On April 24, 1908, an organizing meeting was held at First Presbyterian Church and on June 16, 1908, the organization was formalized at the Odd Fellows Hall. The building opened in July, 1908, and it was the tenth Y.W.C.A. in Illinois. New headquarters were erected at 306 West Jefferson Street in 1921.

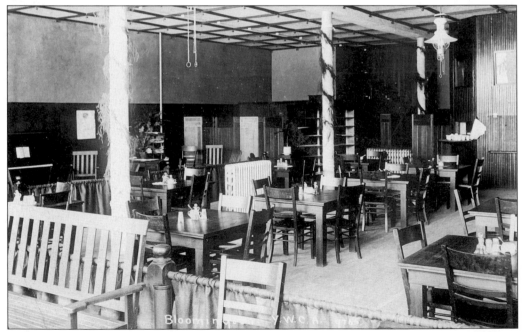

Y.W.C.A. LUNCH ROOM. The lunchroom was located in the B.S. Green building at 111–113 East Monroe Street, and the Y.W.C.A. served its first cafeteria meal here. Members from other areas dined here when they were in town.

Four

EDUCATION

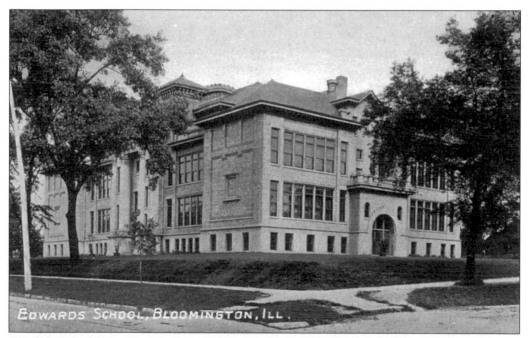

EDWARDS SCHOOL, BLOOMINGTON, ILL.

EDWARDS SCHOOL. This school was built in 1872 at the corner of Monroe and Oak Streets. In 1904, a new building was erected at 801–811 West Market Street (the corner of Market and Allin Streets). The school was named in honor of Richard Edwards who was a president of Illinois State Normal University.

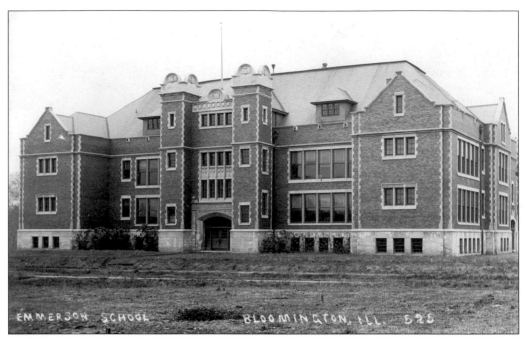

EMERSON SCHOOL. Prior to December 1895, schools were known by the number of the ward in which they were located. The school known as "Ward 4" was renamed Emerson School after Ralph Waldo Emerson. The school was located at 707 South Clinton Street.

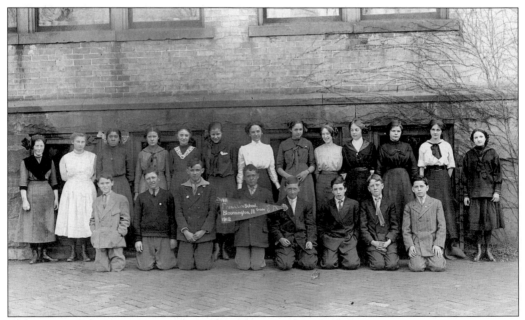

FRANKLIN SCHOOL. The school was erected in 1899 at the corner of Empire and Park Streets at a cost of $25,000. The school was named after Benjamin Franklin. Pictured are the students from grade 8A from the 1911–12 school year.

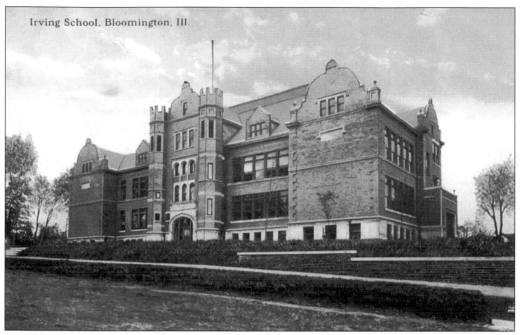

IRVING SCHOOL. Located at 602 West Jackson Street, it was built in 1869 and was named after Washington Irving. In 1905, a new school was built.

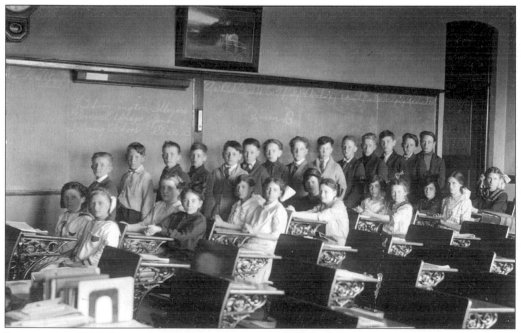

IRVING SCHOOL CLASSROOM. Pictured are the students from grade 7B, Room B, in 1916. Florence Eldridge was the teacher of the class.

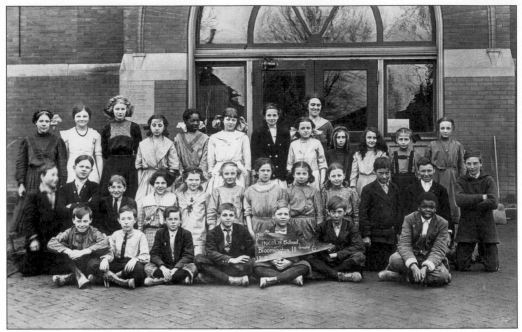

LINCOLN SCHOOL. In 1892, E.M. Van Petten was elected superintendent of the city schools. One of his first improvements was to build Lincoln School in the south part of the city (402–410 West Miller Street.). The school was named after Abraham Lincoln. Pictured are the students from grade six from the 1911–12 school year.

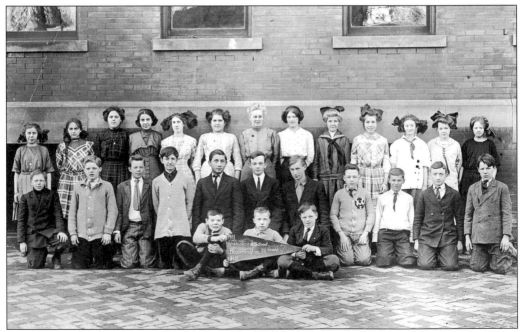

WASHINGTON SCHOOL. Built in 1896 at the corner of State and Washington Streets, this school was named after George Washington. Pictured are students from grade seven from the 1911–12 school year.

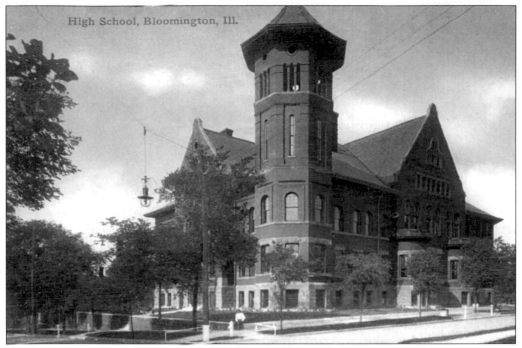

High School, Bloomington, Ill.

BLOOMINGTON HIGH SCHOOL. The first high school was built in 1860 at the corner of Monroe and Oak Streets. In 1864, the first graduating class had 2 members while the class of 1877 had over 30. In 1895, a new school was built at the corner of Monroe and Prairie Streets at a cost of $30,000. In 1916, the school moved to East Washington Street between McLean and Evans Streets.

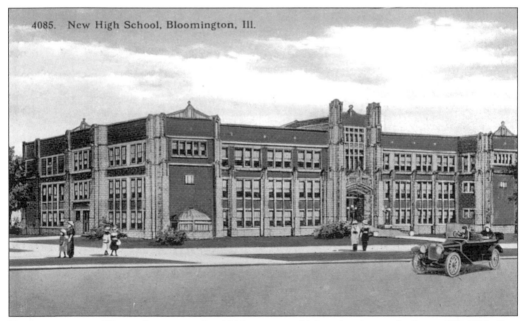

4085. New High School, Bloomington, Ill.

BLOOMINGTON HIGH SCHOOL. In 1916, a new high school was built at 500–518 East Washington Street. It later became the Bloomington Junior High School. The building now houses a variety of businesses.

65

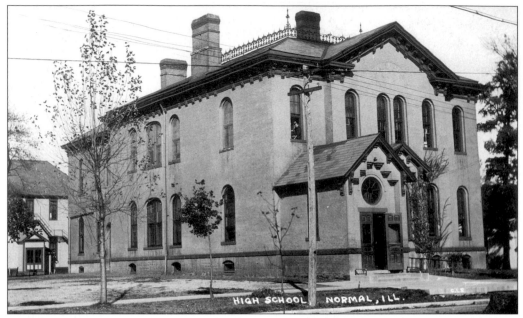

NORMAL HIGH SCHOOL. In 1868, the town of Normal and Illinois State Normal University separated their schools. The high school occupied the new building at the corner of Ash and School Streets, and Henry McCormick was the first principal. The high school offered three years of study and in 1895, added an additional year of study.

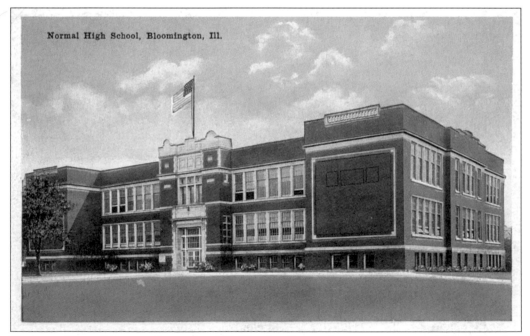

NORMAL HIGH SCHOOL. Located at 303 Kingsley Street, the cornerstone was laid on October 15, 1927, and the dedication was on October 25, 1928. Illinois Masonic Fraternity Grand Master L.L. Emerson was in charge of the dedication ceremony. (Note the error on the card that states the school is in Bloomington.)

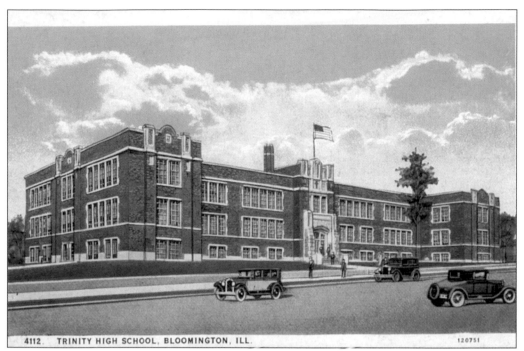

4112. TRINITY HIGH SCHOOL, BLOOMINGTON, ILL. 120751

TRINITY HIGH SCHOOL. The school was built in 1927–1928 at 710 North Center Street at a cost of $285,000. In 1954, the building was expanded at a cost of $300,000.

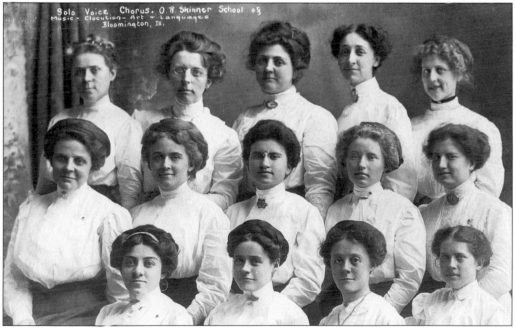

Solo Voice Chorus. O.R. Skinner School of Music- Elocution- Art + Languages Bloomington, Ill.

O.R. SKINNER SCHOOL OF MUSIC. Located in the 400 block of North Main Street in the Eddy Building, the school taught music, elocution, art, and language.

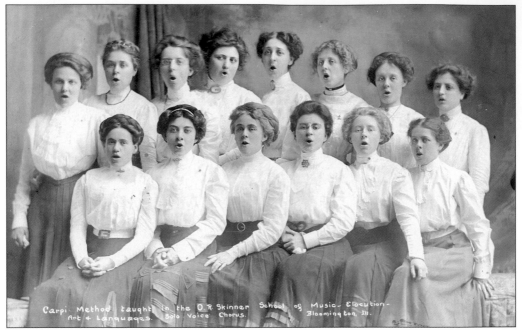

O.R. Skinner School of Music. Pictured are students practicing the Carpi Method of singing.

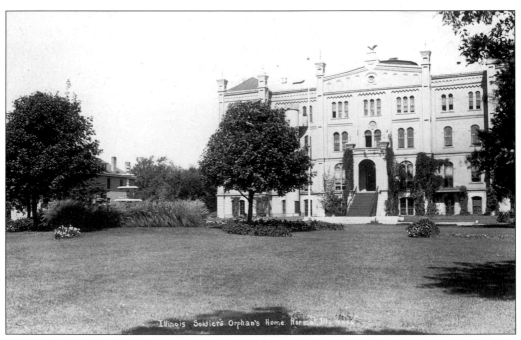

Illinois Soldiers Orphans Home. The school was established in 1865 to provide education and care for indigent children of Civil War veterans. It was located in Bloomington until Jesse Fell donated land for it to be relocated to Normal. In June 1869, the school opened in Normal. In 1904, cottages for housing were built.

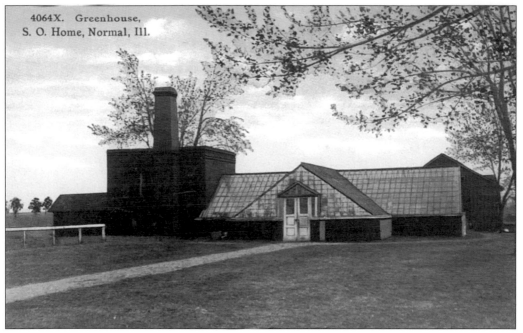

4064X. Greenhouse,
S. O. Home, Normal, Ill.

ILLINOIS SOLDIERS ORPHANS HOME. The administration building was dedicated on June 17, 1869. The school is located on 160 acres and is made up of more than 50 buildings, such as the greenhouse (pictured). From 1929–1975, only veteran's children were housed here.

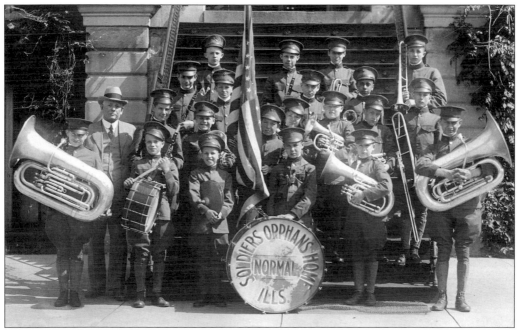

ILLINOIS SOLDIERS ORPHANS HOME BAND. Band members and their instruments are pictured. Ages of members range from 13–16 years of age. The average population of the school was 636 with a breakdown of approximately one-third girls and two-thirds boys.

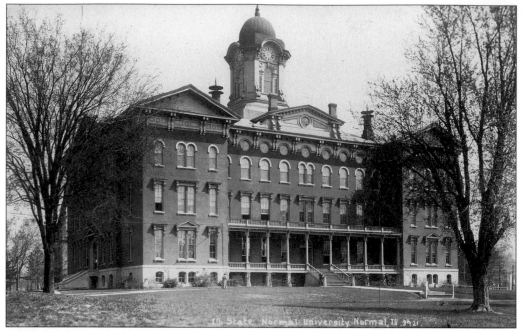

ILLINOIS STATE NORMAL UNIVERSITY. In 1857, I.S.N.U. was founded as the first public university in the state. Due to the efforts of Jesse Fell, I.S.N.U. was located in Normal near the junction of the Illinois Central and Alton Railroads. The Old Main building (pictured) was built in 1861. I.S.N.U. was renamed "Illinois State University" and in 1964, Old Main was torn down.

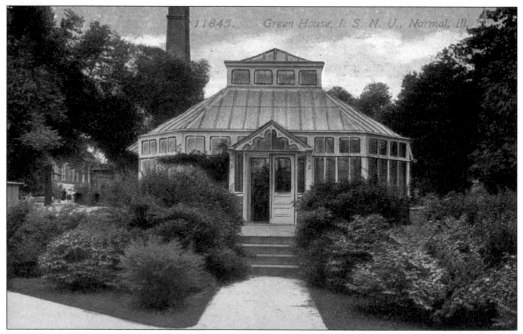

ILLINOIS STATE NORMAL UNIVERSITY. In 1906–1907, the state appropriated $5,500 to build a greenhouse (pictured). The greenhouse was built to fill the need for plants to replace those destroyed in storms or by other means.

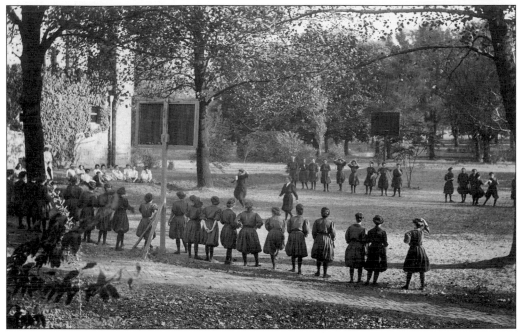

ILLINOIS STATE NORMAL UNIVERSITY. From 1908, this card shows girls in the attire of the period for summer gym class.

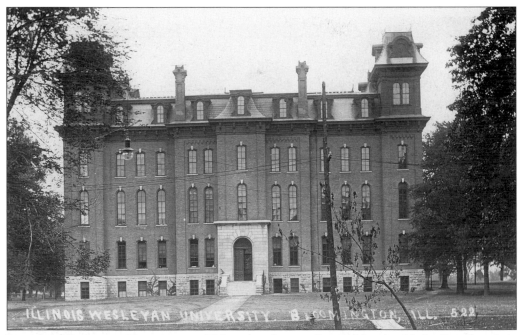

ILLINOIS WESLEYAN UNIVERSITY. This university was founded by the Methodist Church in 1850. Hedding Hall (pictured), also known as Old Main, was built in 1871 at a cost of $100,000. Eleven I.W.U. Presidents had their offices in Hedding Hall. It was destroyed by fire January 9, 1943.

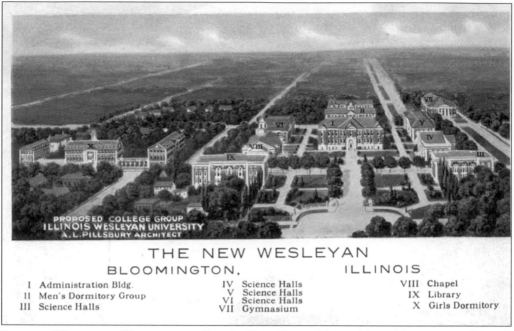

THE NEW WESLEYAN

BLOOMINGTON, ILLINOIS

I Administration Bldg.	IV Science Halls	VIII Chapel
II Men's Dormitory Group	V Science Halls	IX Library
III Science Halls	VI Science Halls	X Girls Dormitory
	VII Gymnasium	

ILLINOIS WESLEYAN UNIVERSITY—BIRD'S EYE VIEW. Pictured is architect A.L. Pillsbury's proposed college group for I.W.U. The New Wesleyan proposal included ten buildings.

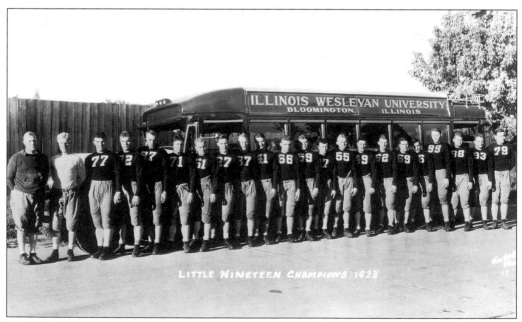

ILLINOIS WESLEYAN UNIVERSITY. Pictured are the "Little Nineteen Champions" and their coach, Skipper "Doc" Elliott (at left), in 1933. The team went undefeated in their conference schedule for the second straight year.

Five
HEALTH CARE

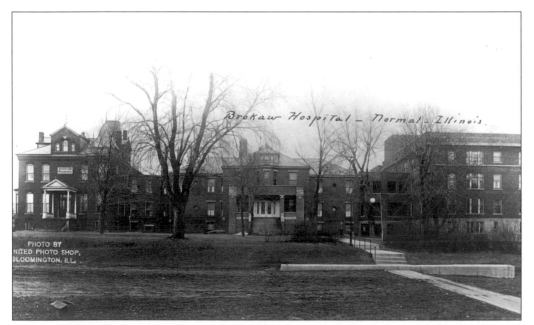

BROKAW HOSPITAL. Located at 1600 Franklin Avenue, Normal, it was built in 1896 and managed by the Mennonite Deaconess nurses. In 1901, Abraham Brokaw donated $30,000 and the name was changed to Brokaw Hospital. In 1984, the hospital merged with Mennonite Hospital and it is now known as Bro-Menn Healthcare Center.

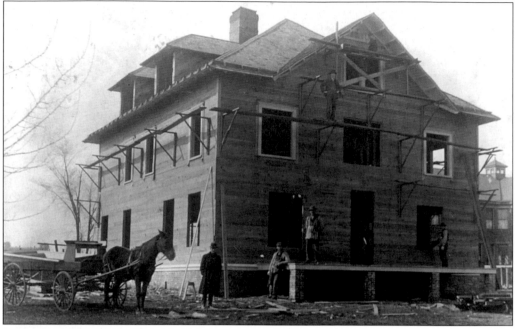

BROKAW NURSES HOME. Picture shows the building still under construction in May 1910. The home was to provide living quarters for nursing staff and students. Brokaw Hospital is in the background.

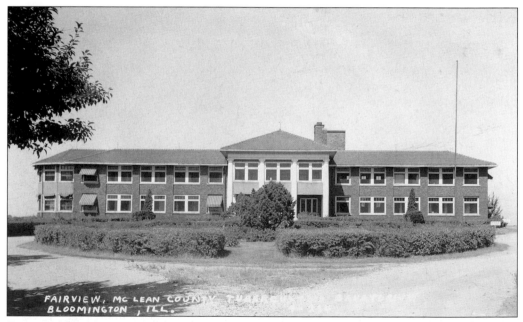

FAIRVIEW, MC LEAN COUNTY THE ... BLOOMINGTON, ILL.

FAIRVIEW TUBERCULOSIS SANATORIUM. In 1918, a meeting was held to establish and maintain an institution for the care and cure of tubercular patients. A public dispensary opened in January 1918, at 103 East Market Street in Bloomington. Later in 1918, 40 acres, at 901 N. Main Street, Normal, were purchased. In the spring of 1919, the Sanatorium was erected and on August 17, 1919, it was dedicated.

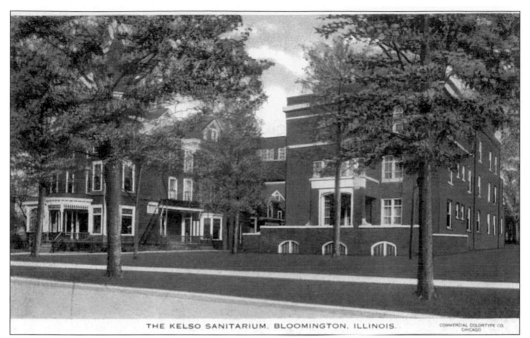

THE KELSO SANITARIUM. BLOOMINGTON. ILLINOIS.

THE KELSO SANITARIUM. Located at 807 North Main Street, it was formerly known as the Bloomington Home Sanitarium. In 1894, Dr. George Kelso and his wife purchased it and renamed it the Kelso Sanitarium. In 1920, it was sold to the Mennonite Association and became Mennonite Hospital.

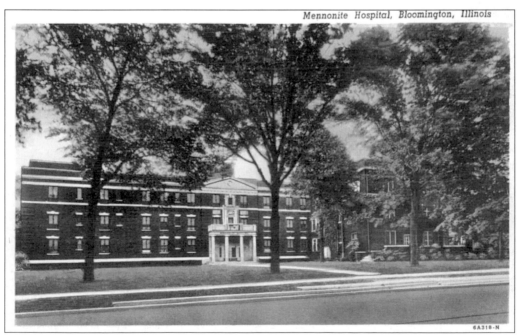

Mennonite Hospital, Bloomington, Illinois

MENNONITE HOSPITAL. On May 1, 1920, the Mennonite Association took possession of the Kelso Sanitarium, which they had purchased for $75,000. In 1984, the hospital merged with Brokaw Hospital forming Bro-Menn Healthcare Center.

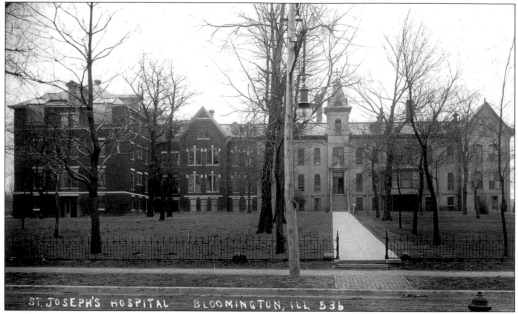

ST. JOSEPH HOSPITAL. Located at 824 West Jackson Street, on the southeast corner of Jackson Street and Morris Avenue, the hospital opened in 1880 and was managed by the Sisters of St. Francis. In 1954, the Marion Unit was built to care for polio patients. In 1969, the hospital relocated to its present site on East Washington Street.

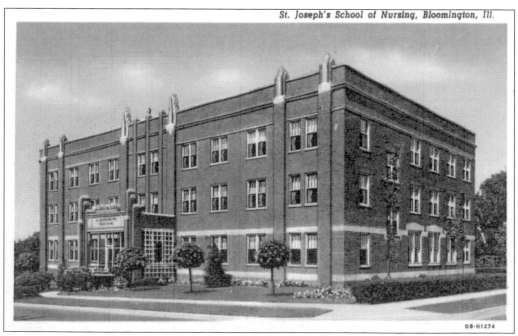

ST. JOSEPH'S SCHOOL OF NURSING EDUCATION. Located at the northeast corner of Morris and Oakland Avenues, it was built in 1928 and closed in 1961. For a time, it housed the McLean County Historical Society. Later, it was razed to make room for the construction of single family housing.

Six

PARKS

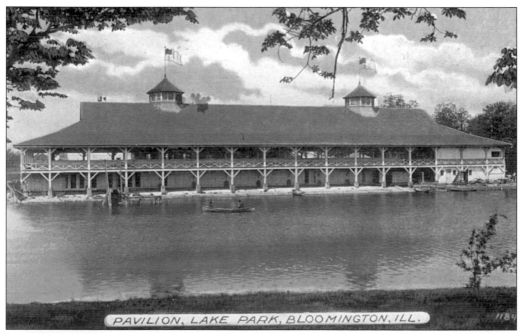

PAVILION, LAKE PARK, BLOOMINGTON, ILL.

LAKE PARK—PAVILION. Farmer Stephen H. Houghton both dredged Houghton Lake and built a house across the road in 1853. The Houghton family also built the pavilion, which could hold about 200 people. The Lake Park area was later known as Bongo Park and is now the site of State Farm Park.

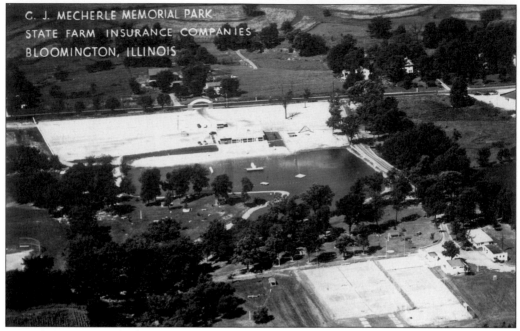

G.J. MECHERLE MEMORIAL PARK. Located at 202 East Hamilton Road, the park is named after George J. Mecherle, founder of State Farm Mutual Insurance Companies. It is a private park, maintained exclusively for State Farm employees and their guests.

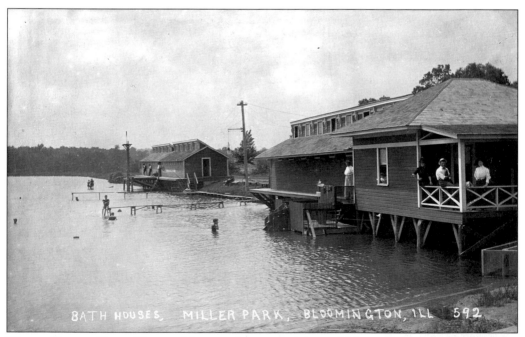

MILLER PARK—BATH HOUSE. The top of the second dam, which was built around 1903, forms a driveway around the west side of the lake. Later, the bath house and beach were added and thousands enjoy swimming in the lake every summer.

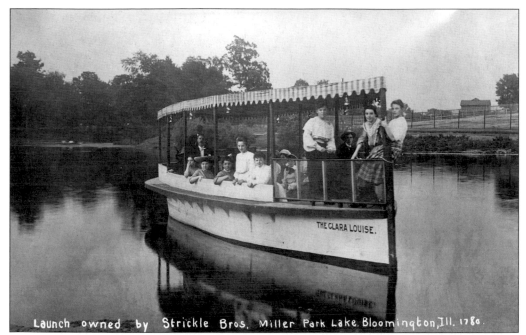

Launch owned by Strickle Bros, Miller Park Lake, Bloomington, Ill. 1780.

MILLER PARK—LAKE AND LAUNCH. An 18-acre lake was created by building two dams across the natural ravine that ran through the park. Pictured is "The Clara Louise," which was owned by the Strickle Brothers.

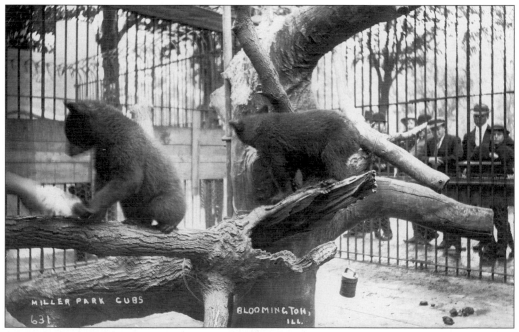

MILLER PARK CUBS BLOOMINGTON, ILL. 631

MILLER PARK—BEAR CUBS. In 1914, the animal house opened. "Big Jim," a bear cub, was raised at the zoo after falling off a circus train near Bloomington.

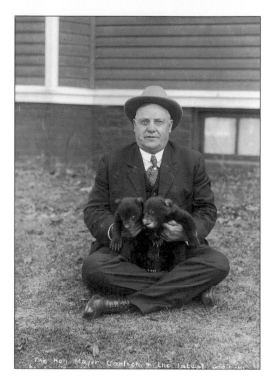

MILLER PARK—BEAR CUBS WITH MAYOR.
Bloomington's Mayor Carlock is pictured with the bear cubs from the zoo.

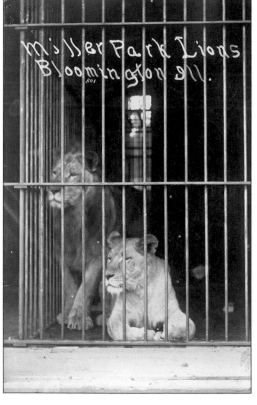

MILLER PARK—LIONS. Pictured are lions, located in the animal house, which was also home to a number of other animals.

Seven

RELIGION

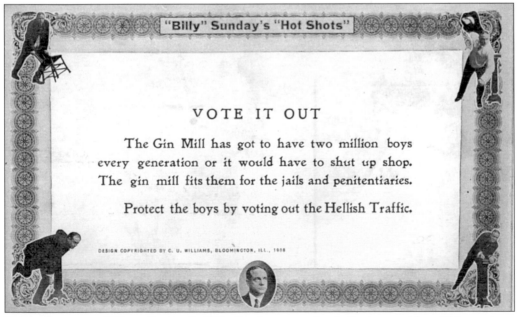

BILLY SUNDAY—"HOT SHOTS." Billy Sunday was a baseball player with a Chicago team before becoming an evangelist. Pictured is an anti-alcohol campaign card distributed by Billy Sunday. The card was published by C.U. Williams.

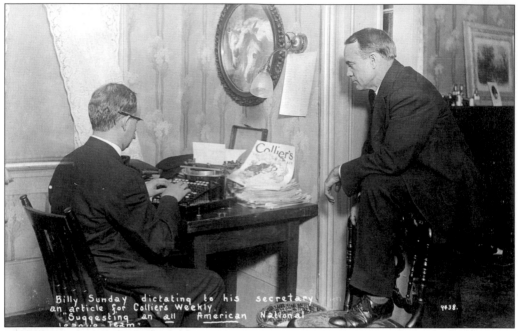

BILLY SUNDAY AND SECRETARY. Billy is dictating an article for *Collier's Weekly*, suggesting an all-American National League team.

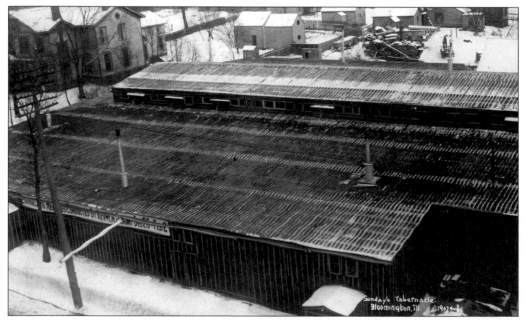

BILLY SUNDAY TABERNACLE. It was located on South Main Street, near the site of today's city hall. Construction of the building was finished in 1907, and the final meeting was held February 2, 1908, with 7,000 in attendance. The subject of the meeting was ending alcohol consumption. On March 3, 1908, the building was sold to W.H. Firke, President of the State Bank of Mansfield for $1,000.

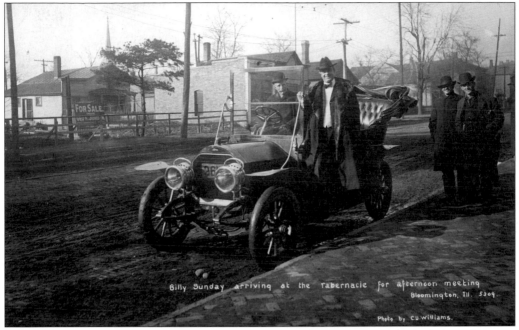

BILLY SUNDAY AT TABERNACLE. Billy is pictured arriving at his tabernacle for an afternoon meeting. The car, owned by Mr. Snow of the Snow and Palmer Dairy, was red, which was unusual for that time period.

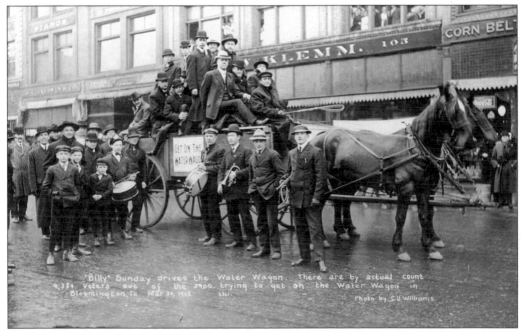

BILLY SUNDAY WATER WAGON. Billy is shown driving his "Water Wagon" on March 30, 1908. The picture was taken on the north side of the square with Klemm's and Corn Belt Drugstore in the background.

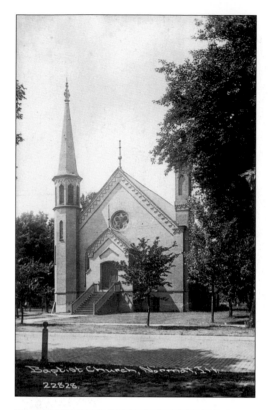

BAPTIST CHURCH—NORMAL. The church was located on the west side of Linden, between First (now Vernon Avenue) and Fourth Streets (now Phoenix Avenue). It was organized July 13, 1866 and was dedicated in 1872. The Reverend John H. Kent was the first pastor.

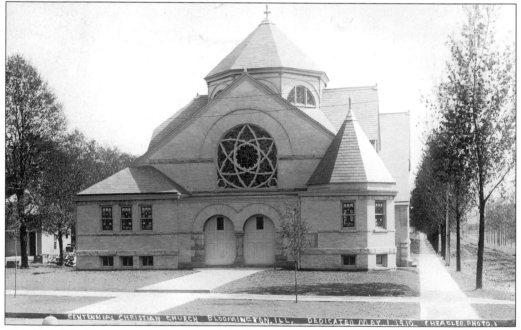

CENTENNIAL CHRISTIAN CHURCH. The lot was purchased February 29, 1909 and was dedicated May 1, 1910. Located at 1219 East Grove Street, on the southeast corner of Grove Street and Willard Avenue, it is still there today.

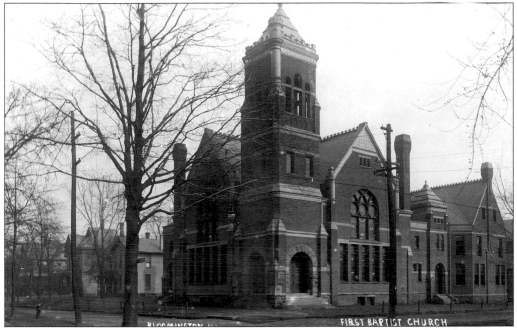

FIRST BAPTIST CHURCH. Dedicated November 25, 1888, this church is located at 401–403 East Jefferson Street, on the southeast corner of Jefferson and Streets. George H. Miller was the architect.

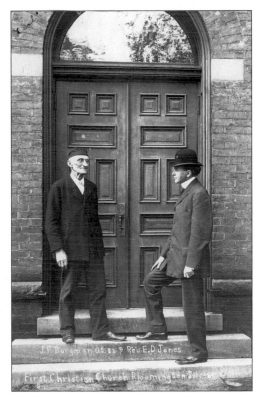

FIRST CHRISTIAN CHURCH. The church was erected in 1873 at 300 North Roosevelt Street and the first pastor was Reverend S.M. Connor. Pictured is Reverend E.D. Jones (on right), and J.F. Burgman, at age 83, who was the former church janitor.

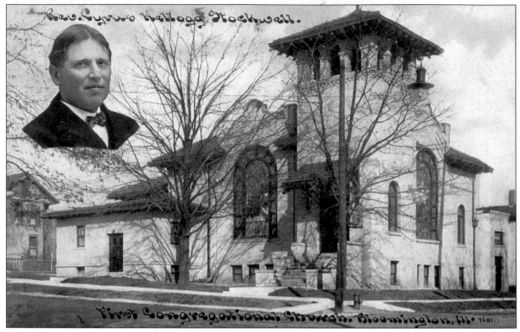

FIRST CONGREGATIONAL CHURCH. Built around 1909, this church was located at 601 North East Street. Reverend Cyrus Kellogg Stockwell is pictured. The building is now the home of the McLean County Arts Center.

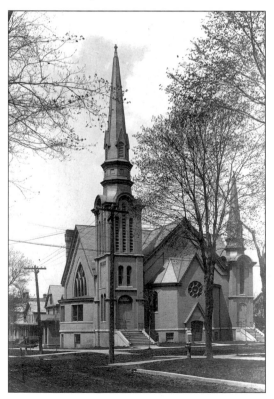

FIRST METHODIST CHURCH—NORMAL. Located on the northwest corner of Fell Avenue and Ash Street, it was the first church in Normal. It was organized on September 5, 1865 and dedicated in June 1867.

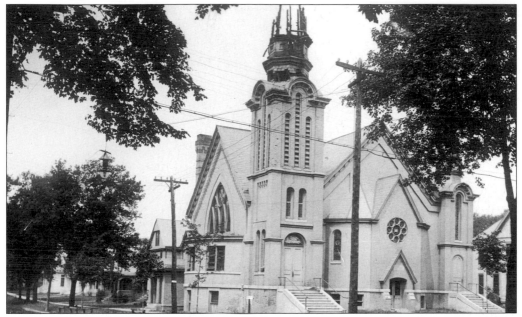

FIRST METHODIST CHURCH—NORMAL. The church was struck by lightning on July 23, 1908, and the picture shows the fire damage caused to the spire.

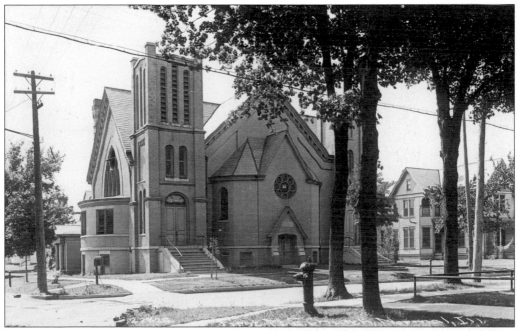

FIRST METHODIST CHURCH—NORMAL. This picture shows the church, minus its spire, which was damaged due to a fire caused by lightning.

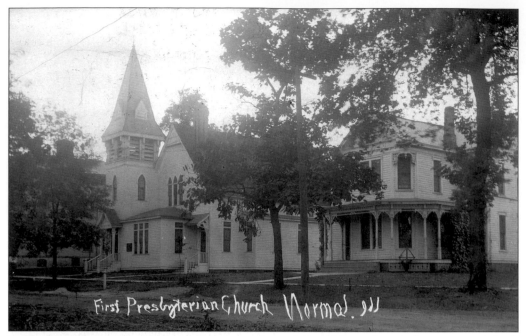

First Presbyterian Church Normal. Ill

FIRST PRESBYTERIAN CHURCH—NORMAL. Erected in 1894, on the northeast corner of Ash and School Streets, this church merged with the Congregational Church and moved into their building on June 26, 1910. A new church was built, on the northeast corner of College and Fell Avenues, and was dedicated on September 20, 1914. The buildings were razed in January 2002.

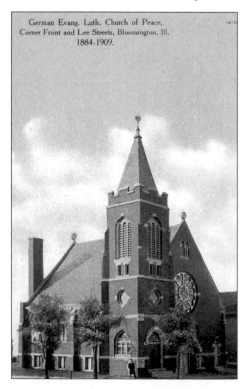

German Evang. Luth. Church of Peace,
Corner Front and Lee Streets, Bloomington, Ill.
1884-1909.

GERMAN EVANGELICAL LUTHERAN CHURCH OF PEACE. The church was built in 1884, on the southwest corner of Front and Lee Streets, and Reverend Alexander Arronet was the first pastor. The picture is from 1909, when the church was celebrating its 25th anniversary.

GRACE METHODIST CHURCH. The church was organized in 1867 and their new building, at 700 North East Street, was completed in 1872. In 1879, the building known as Third Presbyterian Church (on Locust Street near East Street) was purchased. In 1887, work was started on a new church building at the same site and it was dedicated on July 28, 1889.

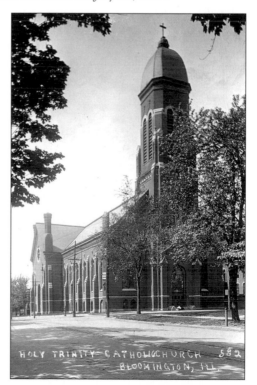

HOLY TRINITY CATHOLIC CHURCH.
Organized by Father Bernard O'Hara, it was founded in 1853. They first met in the old Methodist Church at the corner of Olive and Main Streets. A new church was built, at a cost of $125,000, at 102–104 West Chestnut Street and was dedicated on July 21, 1878. It burned on March 8, 1932 and was rebuilt at a cost of $360,000.

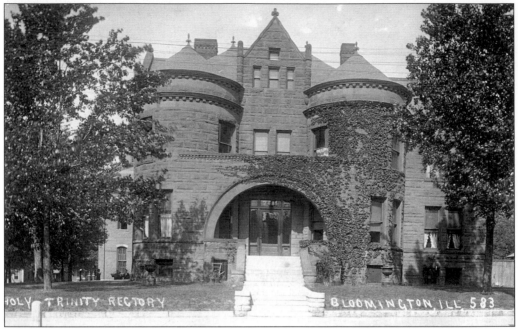

HOLY TRINITY CATHOLIC CHURCH—RECTORY. On July 13, 1872, construction began on the rectory at the northwest corner of Main and Locust Streets. It was completed in early winter of 1873, and is a large dwelling with 13 rooms.

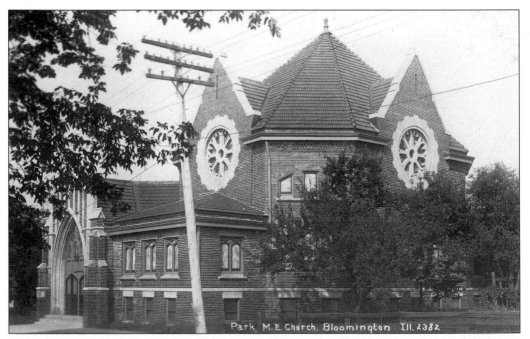

PARK METHODIST EPISCOPAL CHURCH. Located at 704 South Allin Street, the cornerstone was laid October 14, 1906, and the dedication was held on May 26, 1907. The cost of the church was $17,000 and the membership numbered 103. On October 14, 1928, the cornerstone was laid for an education addition, which cost $73,000. It is now known as Park United Methodist Church.

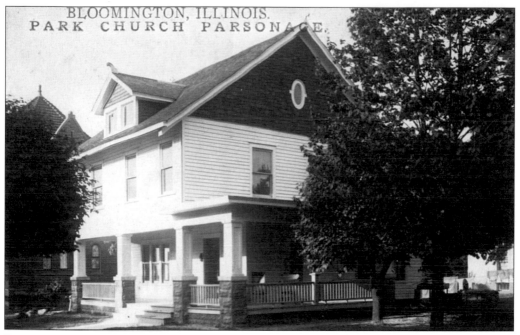

PARK METHODIST EPISCOPAL CHURCH—PARSONAGE. The house was maintained as a home for the church pastor and was located on the northeast corner of Allin and McArthur Streets.

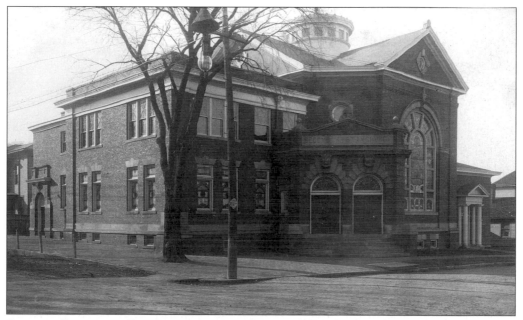

SECOND CHRISTIAN CHURCH. Incorporated on April 22, 1901, and dedicated on November 23, 1902, it was located at 411 East Mulberry Street. The Reverend J.H. Gilliland was the first pastor.

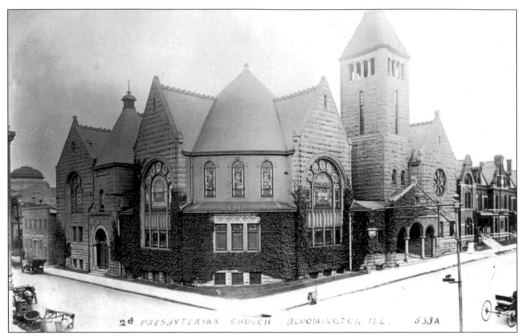

SECOND PRESBYTERIAN CHURCH. The organizing meeting was held on June 24, 1855, in Majors Hall on East Front Street. On March 10, 1873, a new church was proposed. The cornerstone was laid October 15, 1895, and the dedication was held on December 13, 1896. It is located at 313 North East Street.

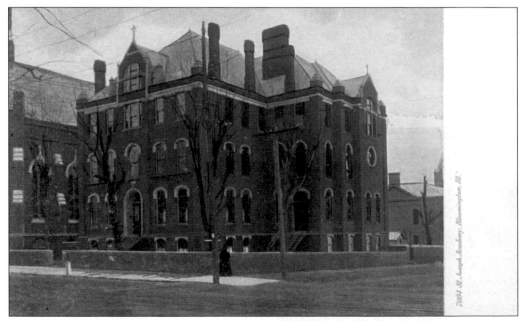

ST. JOSEPH'S ACADEMY. Built in 1863 to provide living quarters for nuns and young lady boarders, it was located on the southeast corner of Chestnut and Center Streets. On February 15, 1884, at 10 a.m., a fire was discovered in the roof and 300 boys and girls escaped unharmed. It was demolished in November 2001, to provide for the expansion of Holy Trinity's parking lot.

St. Mary's Catholic Church. Located at 527 West Jackson Street, the cornerstone was laid on October 4, 1868. In the spring of 1927, a school and community hall were built next to the church at a cost of $125,000.

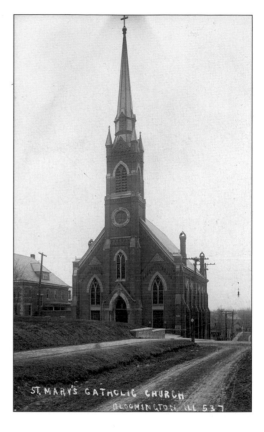

St. Patrick's Church, Bloomington, Ill.

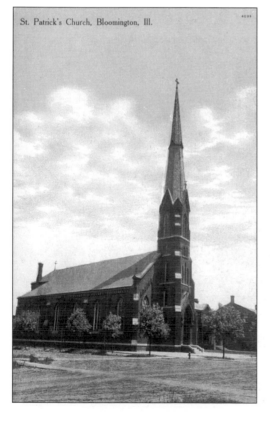

St. Patrick's Church. Established in 1892, the dedication was June 11, 1893. The church is located at 1209 West Locust Street, and St. Patrick's School was next to the church at 1205 West Locust Street.

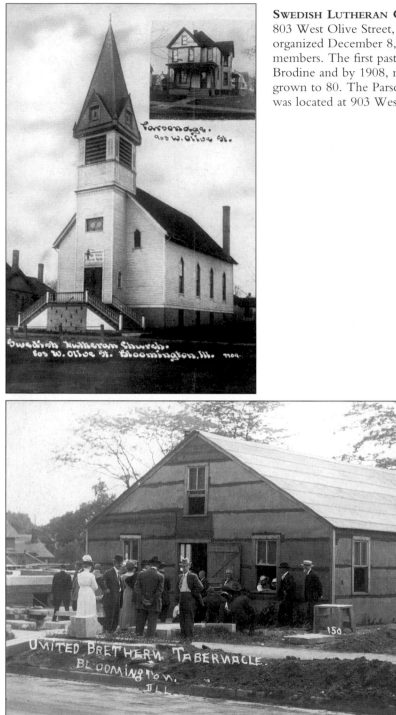

SWEDISH LUTHERAN CHURCH. Located at 803 West Olive Street, the church was organized December 8, 1872, with 38 members. The first pastor was Reverend P.J. Brodine and by 1908, membership had grown to 80. The Parsonage (inset in picture) was located at 903 West Olive Street.

UNITED BRETHERN TABERNACLE. In 1873, this church was located at 508 East Front Street. They later relocated to the northwest corner of Center and Locust Streets, which is now the site of Trinity Grade School.

Eight
RESIDENCES

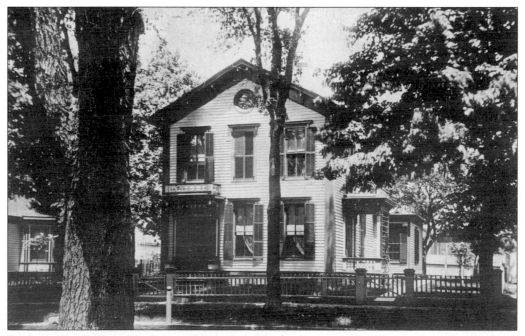

RESIDENCE OF REUBEN MOORE BENJAMIN. The house, at 510 East Grove Street, was built for John Routt and was purchased in 1856 by Benjamin. Mr. Benjamin was a well-known lawyer who helped draft the state of Illinois constitution in 1870. The architecture is in the Greek Revival style and the house is still there.

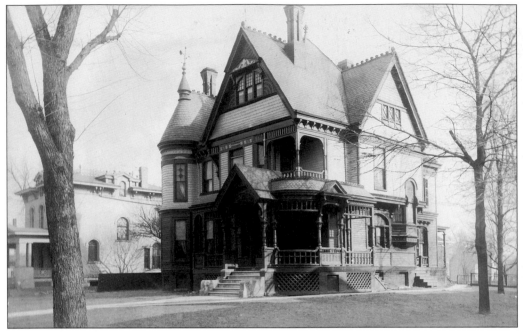

RESIDENCE OF EDWARD B. GRIDLEY. In 1887, this home was built for Gridley, owner of McLean County Bank, at 409 East Grove Street. The style of the house was Queen Anne, and George W. Miller was the architect. The house still stands today.

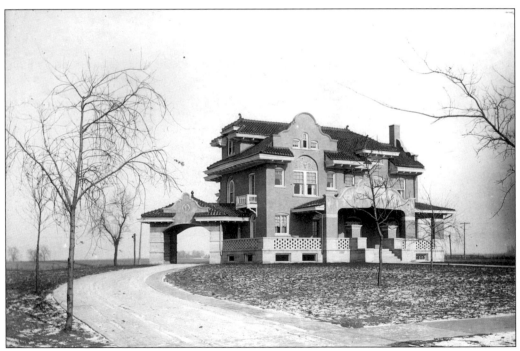

RESIDENCE OF CHARLES A. VANPELT. In 1910, this home was built for Mr. VanPelt at 1700 East Washington Street, and George H. Miller was the architect. The home was torn down in June 1987, to expand neighboring property.

Nine
SPECIAL EVENTS

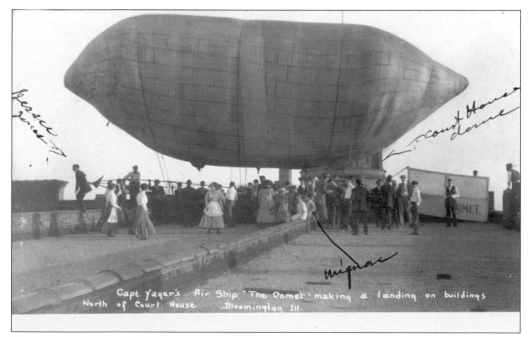

Capt. Yager's Air Ship "The Comet" making a landing on buildings
North of Court House. Bloomington Ill.

AIRSHIP OF CAPTAIN YAGER. On September 15, 1910, "The Comet" landed on the roof of Klemm's Department Store (on West Jefferson Street). After being on the roof for approximately 30 minutes, Captain Yager and his airship departed.

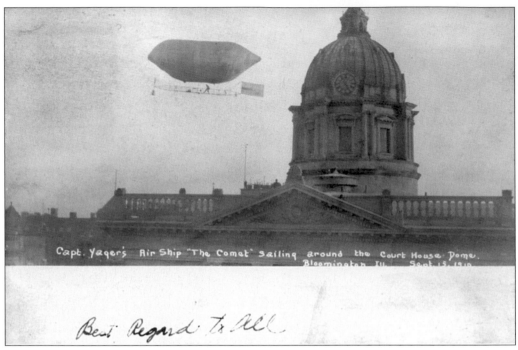

Capt. Yager's Air Ship "The Comet" sailing around the Court House Dome. Bloomington Ill. Sept. 15. 1910.

Best Regard To All

AIRSHIP OF CAPTAIN YAGER. After leaving the roof of Klemm's Department Store, "The Comet" circled the courthouse before flying to Whites Place.

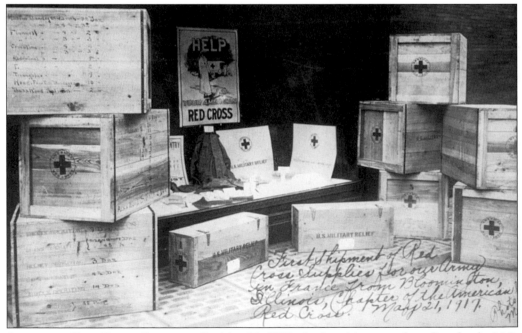

First Shipment of Red Cross Supplies for our Army in France From Bloomington, Illinois, Chapter of the American Red Cross. May 21, 1917.

AMERICAN RED CROSS SUPPLIES. On May 21, 1917, the first shipment of supplies, for the U.S. army in France, was sent from the Bloomington, Illinois, Chapter of the American Red Cross.

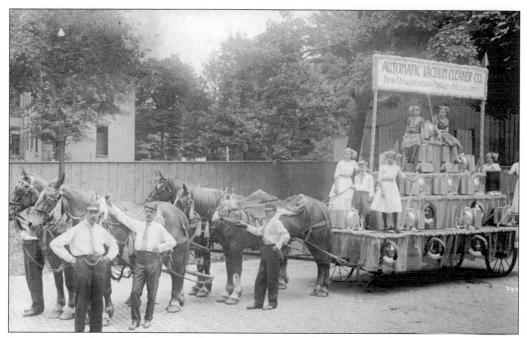

AUTOMATIC VACUUM CLEANER COMPANY. A Manufacturer's Parade was held on June 20, 1911, to show and promote products that were manufactured locally. This business was located at 217-219 East Douglas Street.

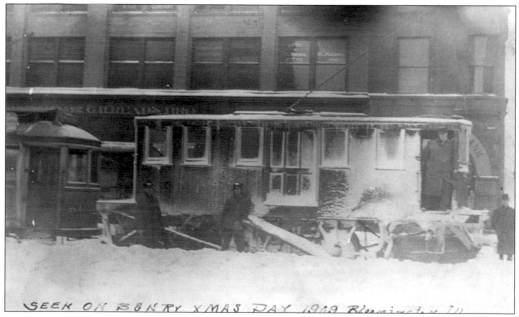

BLOOMINGTON AND NORMAL RAILWAY. The view shows a streetcar in the 200 block of North Main Street on Christmas Day, 1909. In the background are Reads (left) and McLean County Bank (right).

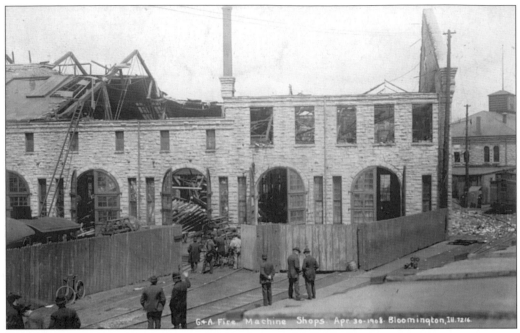

CHICAGO AND ALTON MACHINE SHOPS. On April 30, 1908, at 5 p.m., a fire was seen coming from the third floor, which was used as a storeroom. The dollar damage totaled between $15,000 and $20,000. The cause of the fire was thought to be crossed electrical wires.

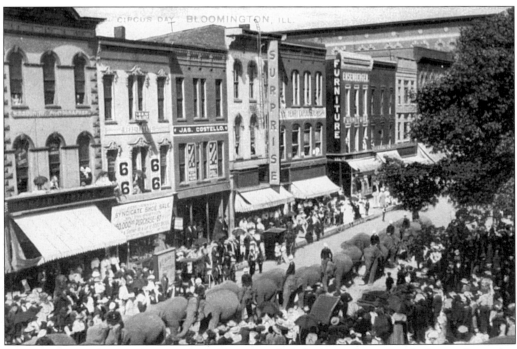

CIRCUS DAY. The Ringling Brothers Circus paraded elephants down South Center Street (on West side of square) on Thursday, September 6, 1906.

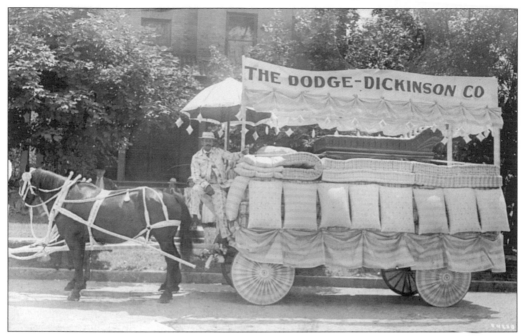

THE DODGE DICKINSON COMPANY. On January 1, 1909, they occupied their new building at 816 East Grove Street. The view shows their parade float in the Manufacturer's Parade on June 20, 1911. The company manufactured mattresses and couches.

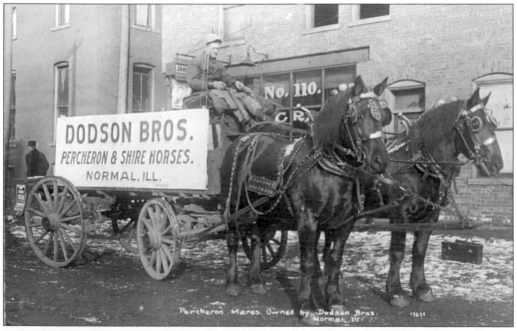

DODSON BROTHERS—NORMAL. The brothers sold percheron and shire horses, and were famous worldwide as horse importers. The view shows their horse-drawn wagon, featuring their advertising sign on the side.

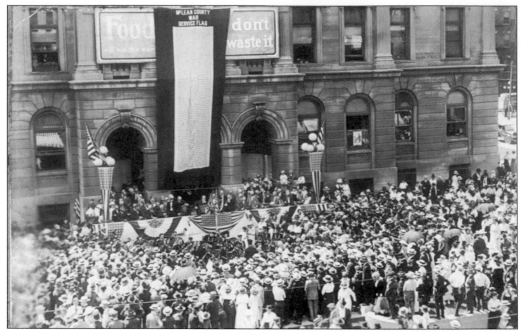

FLAG DEDICATION. On June 13, 1918, the McLean County service flag was unfurled and hung on the east side of the courthouse. The flag contained 3,000 stars. The afternoon's music was furnished by the Bloomington Band, directed by George Morton, and the Soldiers Orphans Home Band of Normal.

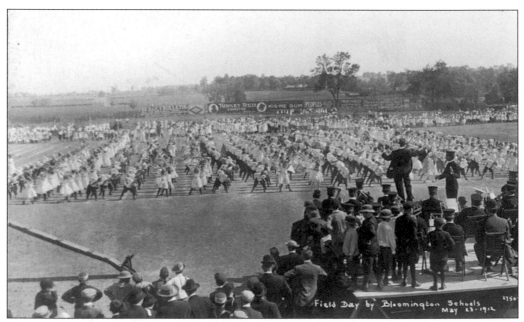

FIELD DAY. The Bloomington Schools held a field day on May 23, 1912. The event was held at the South Side Baseball Park, and no cars or carriages were allowed in the park during the exercises. Spaces were measured off and numbered for various schools and the Washington School PTA sold sandwiches for "two for five cents" to raise money to pay for a new piano.

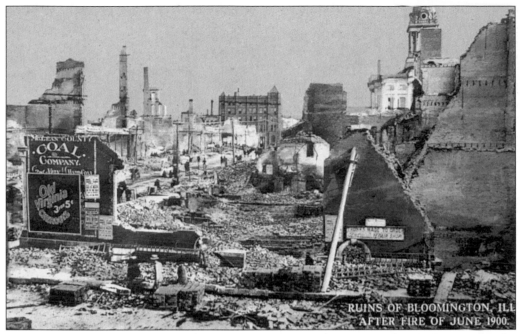

FIRE AFTERMATH. The view is of the southwest corner of Monroe and Main Streets after the fire of June 1900. The fire began in the Model Laundry on the Southwest corner of Monroe and East Streets. Over four square blocks were consumed by the fire. Among the buildings destroyed was the courthouse.

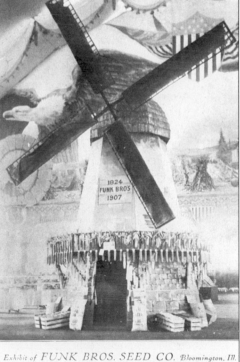

Exhibit of FUNK BROS. SEED CO. Bloomington, Ill. At the National Corn Exposition, Chicago, Ill., October 5 to 19, 1907

FUNK BROTHERS EXHIBIT. The National Corn Exposition was held in Chicago from October 15–19, 1907, and featured a windmill decorated by the Funk Brothers Seed Company.

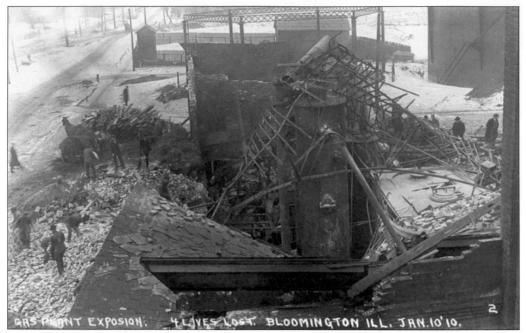

GAS PLANT EXPLOSION. On January 10, 1910, at 2:18 p.m., a crew attempted to extend a ten-inch gas main at the Union Gas Company Plant. Seeping gas, ignited by a gas burner's pilot light, caused the explosion. The building was located north of Washington Street and west of Chicago and Alton Railroad tracks.

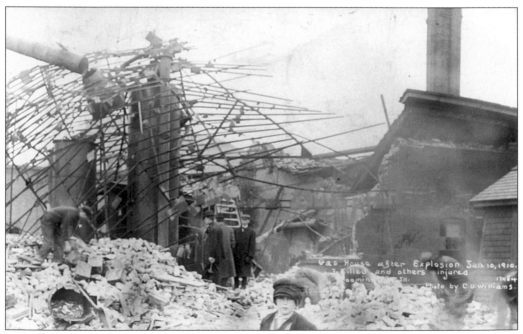

GAS PLANT EXPLOSION. As a result of the explosion, three were killed and six were injured. The building itself was leveled. Gas service was restored one week later.

GRAND OPERA HOUSE. The Opera House was built in 1890, at 108 East Market Street and opened in February 1891. The building burned to the ground on May 1, 1909. The view shows the aftermath of the fire. The building was rebuilt in 1910 and named "The Chatterton" after owner George W. Chatterton.

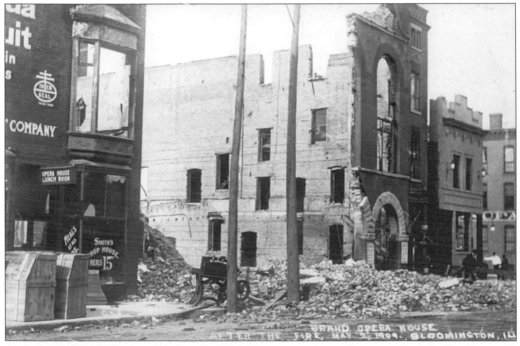

GRAND OPERA HOUSE. The view shows the caved-in front wall as a result of the fire. In 1923, it was renamed "Illini" and it closed in the 1930s. In 1952, State Farm converted the building into office space.

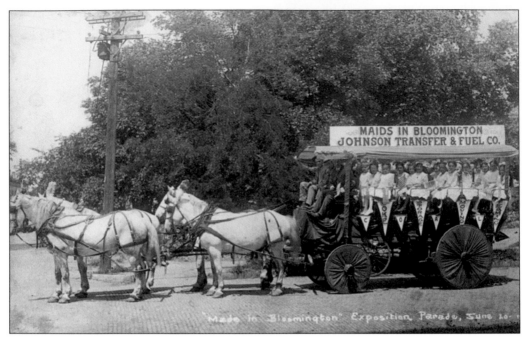

JOHNSON TRANSFER AND FUEL COMPANY. "Maids in Bloomington" was the sign on their float in the Manufacturer's Parade on June 20, 1911. Their office was located at 401-417 South Center Street and the stables were on Mason Street between North (now Monroe) and Market Streets.

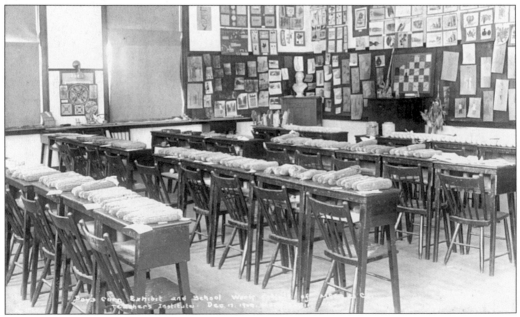

MCLEAN COUNTY TEACHER'S INSTITUTE. On December 17, 1909, local boys showed corn and school work exhibits. The National Corn Contest was won by a 17-year-old North Carolina boy who produced 152 1/2 bushels of corn on one acre. The corn sold for $2 a bushel.

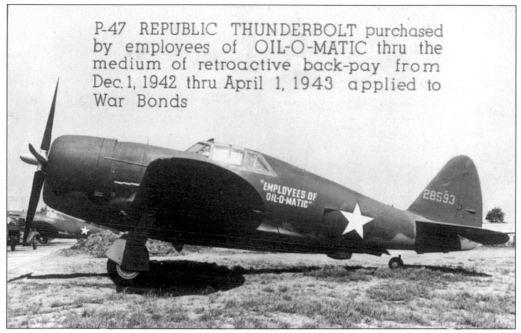

P-47 REPUBLIC THUNDERBOLT. This airplane was purchased by employees of Oil-O-Matic through the medium of War Bonds purchased from December 1, 1942, through April 1, 1943.

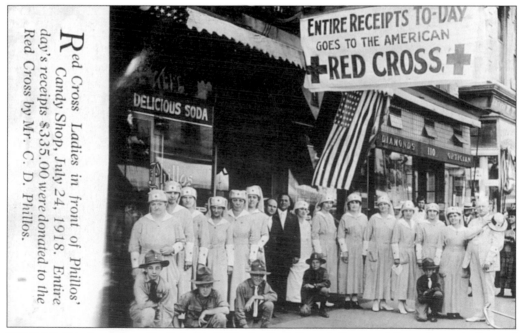

PHILLOS' CANDY SHOP. On July 24, 1918, the Red Cross ladies posed for a picture in front of Phillos' Candy Shop at 108 North Center Street. Mr. C.D. Phillos donated the Shop's receipts for the day, totaling $335, to the Red Cross.

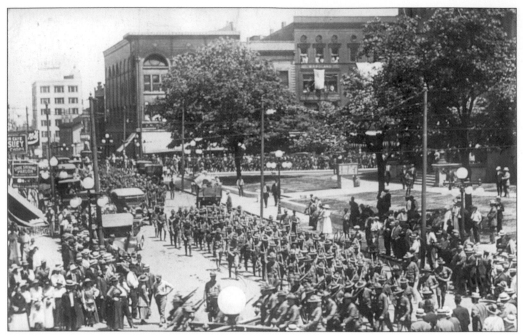

STREETCAR STRIKE. Due to the strike on July 7, 1918, the Illinois National Guard was called in to enforce martial law. The streetcar motormen wanted shorter hours and higher wages. The view is of the National Guard on Center Street on the west side of the courthouse.

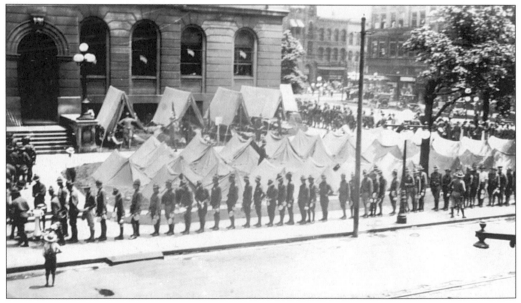

STREETCAR STRIKE. The Illinois National Guard are shown standing in the chow line. Frank Ensenberger, owner of Ensenberger's Department Store, took the postcard photo. (Ensenberger's was on Center Street on the west side of the courthouse.)

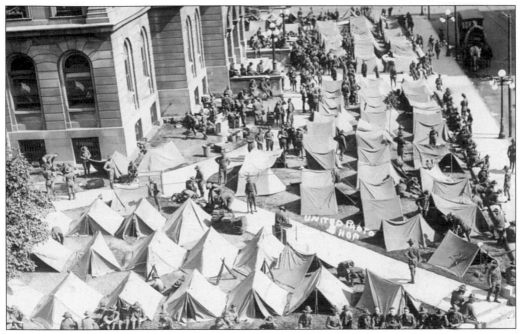

STREETCAR STRIKE. The view shows the tents of the Illinois National Guard on the lawn of the courthouse. The message on the back of the card said that these are "the soldier boys who used to wake us up at 4 o'clock every morning. There were 2,000 in town and they almost looked like swarms of bees on the streets."

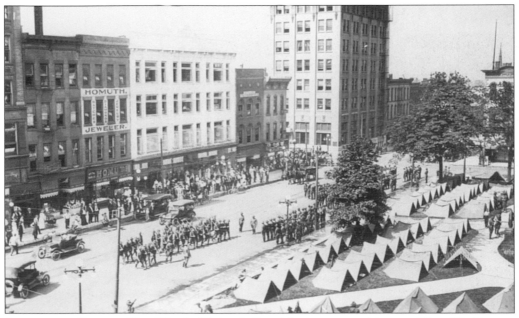

STREETCAR STRIKE. The Illinois National Guard is shown marching on West Washington Street on the south side of the courthouse. By July 9, 1917, the Railway Company and the street car union reached an agreement and signed a contract. The motormen's starting salary was raised to $2.35 per day.

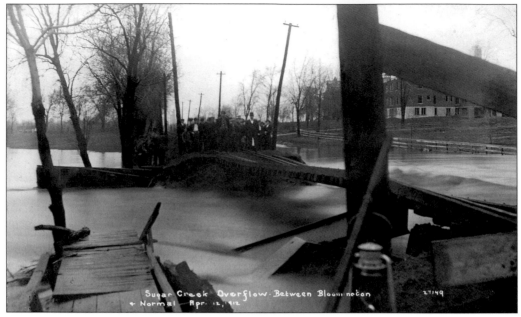

SUGAR CREEK OVERFLOW. The view, from April 12, 1912, shows the flooding due to the overflow of Sugar Creek. Due to the heavier than usual rainfall in the spring of 1912, all the streams and rivers in the Midwest were overflowing and causing flooding.

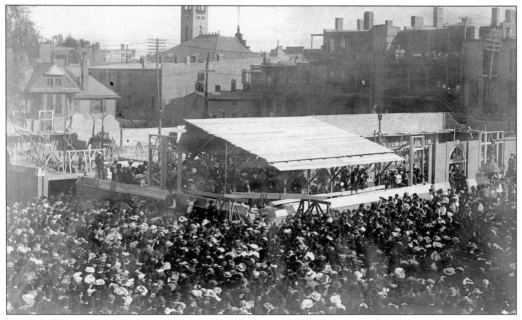

Y.M.C.A. CORNERSTONE LAYING CEREMONY. The cornerstone laying ceremony was held on September 22, 1907, for the new Y.M.C.A at 201-205 East Washington Street, on the southeast corner of Washington and East Streets. The dedication ceremony was held September 23, 1907, and was attended by Vice President Charles Fairbanks and former Vice President Adlai Stevenson. The Y.M.C.A. opened Friday, June 1, 1908.

Ten
STREET SCENES

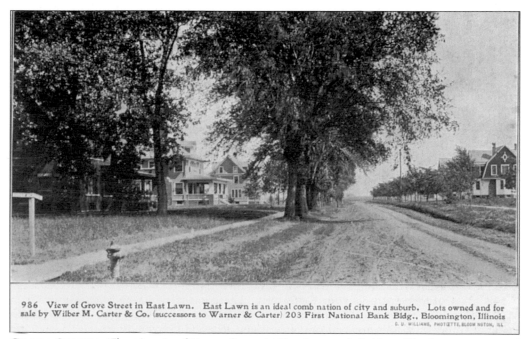

986 View of Grove Street in East Lawn. East Lawn is an ideal comb nation of city and suburb. Lots owned and for
sale by Wilber M. Carter & Co. (successors to Warner & Carter) 203 First National Bank Bldg., Bloomington, Illinois
C. U. WILLIAMS, PHOTETTE, BLOOM NGTON, ILL

GROVE STREET. The view is of Grove Street in East Lawn subdivision. The lots were owned and for sale by Wilber M. Carter and Company.

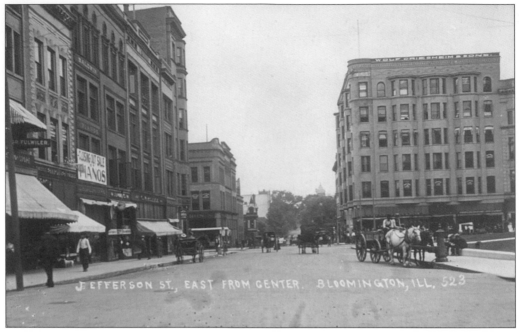

JEFFERSON STREET. In 1870, pine block pavement was put down on Jefferson Street during T.J. Bunn's tenure as Mayor. Pictured is Jefferson Street looking east from Center Street on the north side of the courthouse. Note the water fountain for horses on the right.

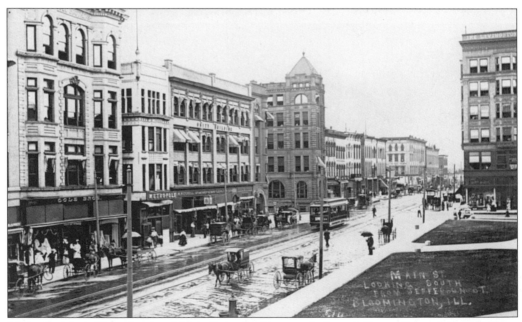

MAIN STREET. The view is of Main Street looking south from Jefferson Street. Pictured, from left to right, are Cole Brothers, Metropole Hotel, Kitchell's, German American Bank, G.H. Reads, McLean County Bank, First National Bank (on corner south of Washington Street), and Ike Livingston and Sons (at far right).

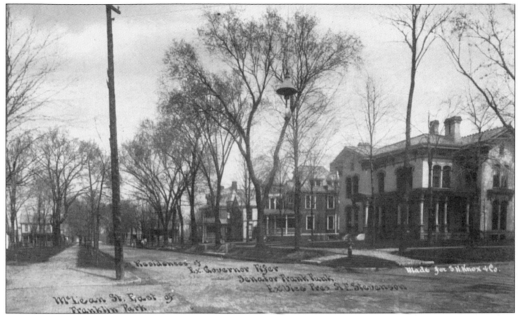

McLean Street. The view is of McLean Street on the east side of Franklin Park. Pictured are the residences of Ex–Governor Fifer, Senator Frank Funk, and Ex–Vice President Adlai E. Stevenson.

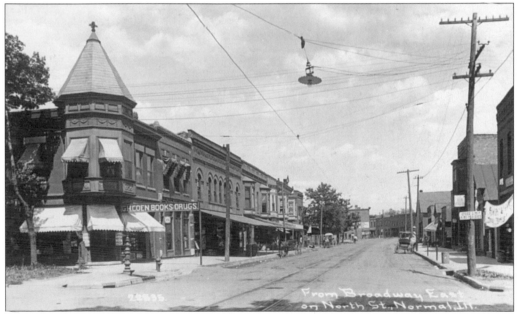

North Street, Normal. The view shows North Street looking east from Broadway. Note the sign on the pole (at right) that states "Speed Limit 8 MI Per Hour." The G.H. Coen Drug Store is on the corner (to the left).

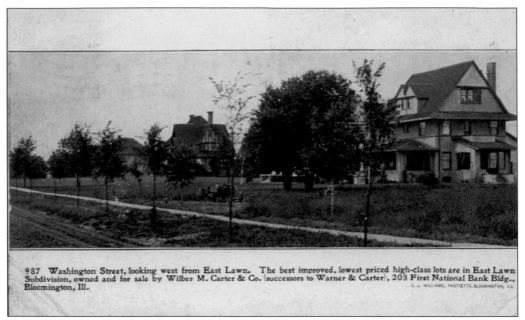

987 Washington Street, looking west from East Lawn. The best improved, lowest priced high-class lots are in East Lawn Subdivision, owned and for sale by Wilber M. Carter & Co. (successors to Warner & Carter), 203 First National Bank Bldg., Bloomington, Ill.
C. J. WILLIAMS, PHOTIETTE, BLOOMINGTON, ILL.

WASHINGTON STREET. The view is of Washington Street looking west from East Lawn subdivision. The lots were owned and for sale by Wilber M. Carter and Company.

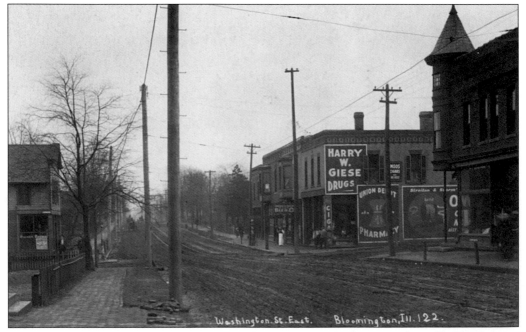

Washington.St.East. Bloomington,Ill.122.

WASHINGTON STREET. The view is of Washington Street looking east from Morris Avenue. Pictured is the Harry W. Giese Drug Store, which was on the southeast corner of Washington Street and Morris Avenue.

114

Eleven
TRANSPORTATION

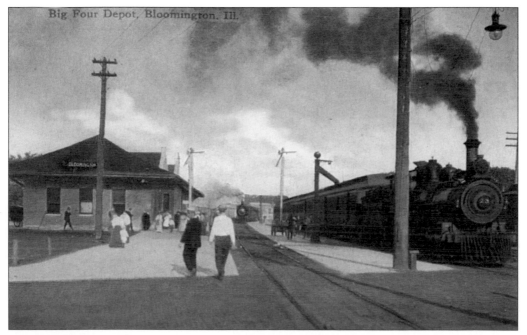

BIG FOUR DEPOT. The passenger depot was located at 424 South Main Street, the freight depot at 431 South Main Street, and the freight office at 417 South Main Street. M.C. Boyce was the freight agent.

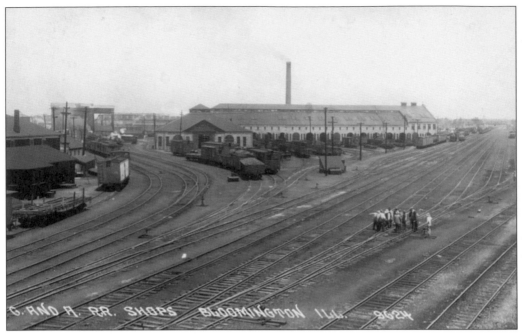

CHICAGO AND ALTON RAILROAD SHOPS. The shops were located between Seminary and Chestnut Streets. The first Pullman car was built here and sent to Chicago on September 1, 1859. In 1882, the first reclining chair car was built.

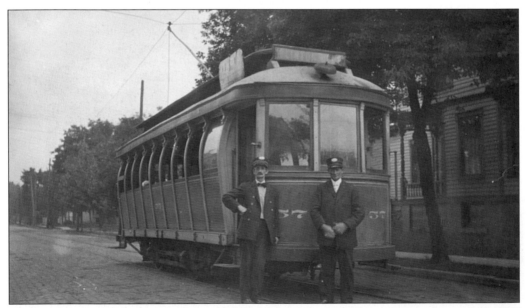

CLINTON BELT STREETCAR. The motorman and conductor are standing in front of the #57 streetcar. The car traveled south on Clinton and met up with the East Side line on Front Street. The sign on the side of the car (at the top) contained an advertisement for A. Livingston and Sons.

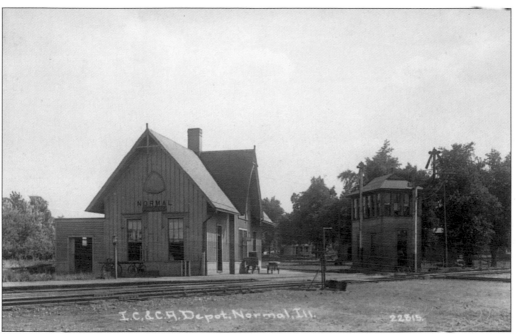

ILLINOIS CENTRAL AND CHICAGO AND ALTON DEPOT—NORMAL. The switch tower is at the right of the picture with a railroad employee standing in the doorway.

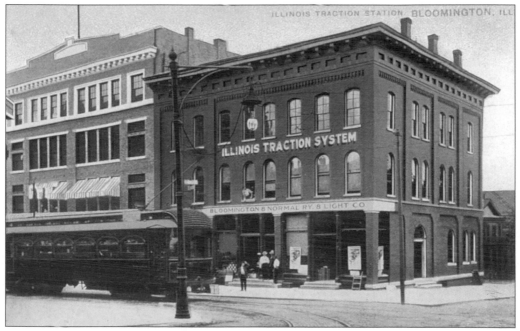

ILLINOIS TRACTION STATION. The station was located on the southwest corner of Madison and Jefferson Streets. In 1906, the first cars went from Decatur to Bloomington with 28 1/2 miles of track in McLean County. The Illinois Traction terminal closed on February 21, 1953.

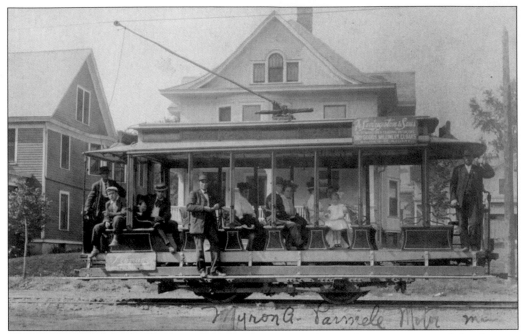

STREETCAR ON EAST FRONT STREET. Myron A. Parmele was the motorman, and the signs on the car were advertisements for Newman's and A. Livingston and Sons. The house in the background was razed in 1969 or 1970, to make room for a parking lot for Wesley Methodist Church.

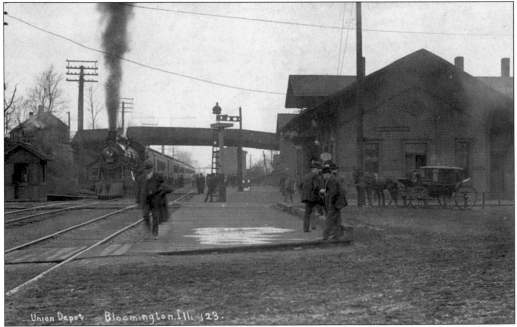

UNION DEPOT. The depot was located at 1100 West Washington Street. The horse-drawn, enclosed carriage (at right) was used for transportation to and from the depot. The bridge over the tracks (center) carried traffic on West Front Street.

Twelve

MISCELLANEOUS

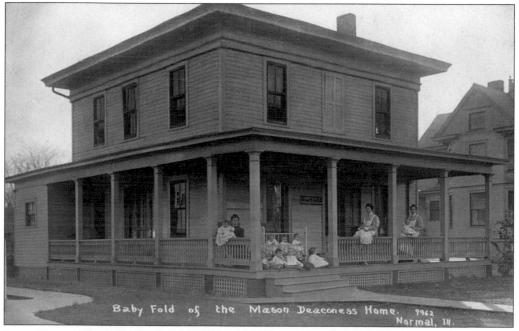

Baby Fold of the Mason Deaconess Home. 9962 Normal, Ill.

BABY FOLD. The Baby Fold was organized in 1902, in the home of Mrs. Nancy Mason, at 309 North Street, Normal. In May 1910, the Baby Fold moved to 108 East Willow Street. Mrs. T.W. Asher was the Superintendent from 1908 to 1935.

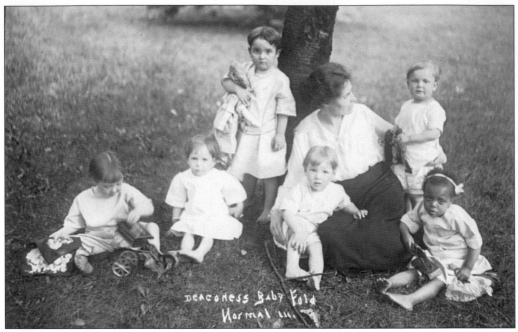

BABY FOLD. The Baby Fold was a home for the temporary care of children whose parents could not care for them. Pictured are children in the yard of the Baby Fold at 309 North Street, Normal.

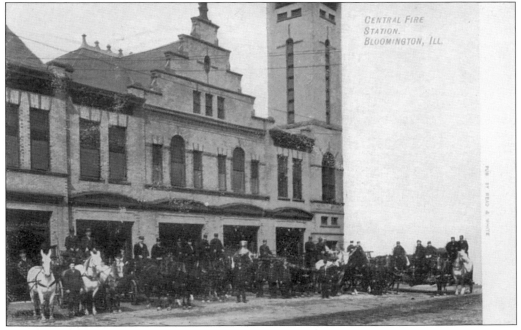

CENTRAL FIRE STATION. The station opened on June 3, 1902 at 222-28 East Front Street. The building cost $29,000 and the lot another $7,000. The building is now the home of Central Station Restaurant.

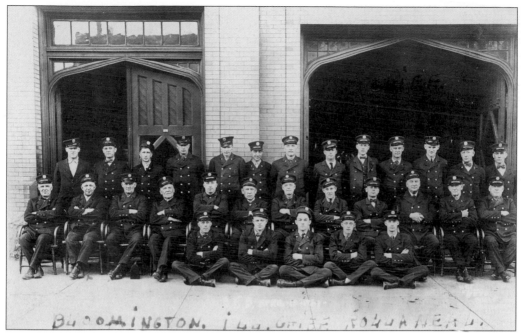

CENTRAL FIRE STATION—BLOOMINGTON FIRE DEPARTMENT. The firemen posed for pictures in front of the Central Fire Station on April 16, 1921. Rolla Neal was the Fire Chief.

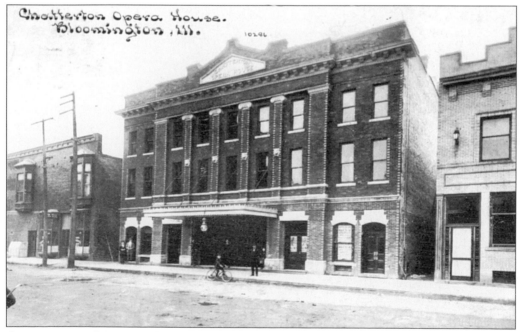

CHATTERTON OPERA HOUSE. The Grand Opera House, which was at 106–114 East Market Street, burned to the ground on May 1, 1909. It was rebuilt in 1910, and renamed for the new owner, George W. Chatterton. The Opera House closed in the 1930s.

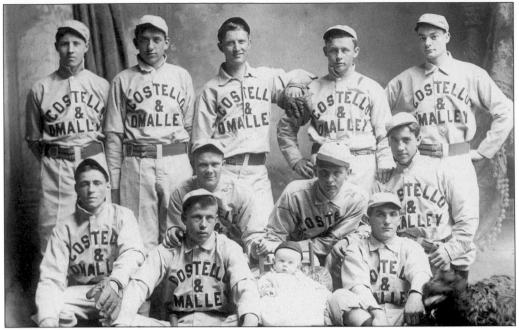

COSTELLO AND O'MALLEY. The picture is from around 1908, and is of the baseball team sponsored by Costello and O'Malley Men and Boys Clothing Store. The store was located at 317 North Main Street.

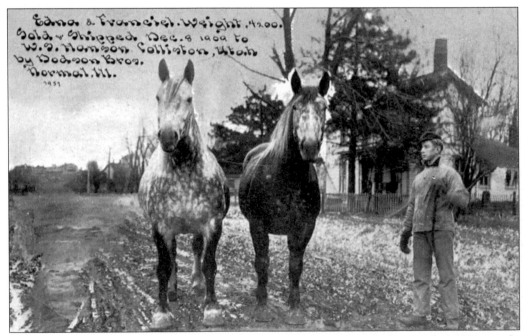

DODSON BROTHERS OF NORMAL. Pictured are Edna and Franciel who weigh 4,200 pounds. They were sold and shipped to W.S. Hanson of Colliston, Utah, on December 8, 1909. Normal was known nation-wide for horses, with the better known dealers being Dillion Brothers and Dodson Brothers.

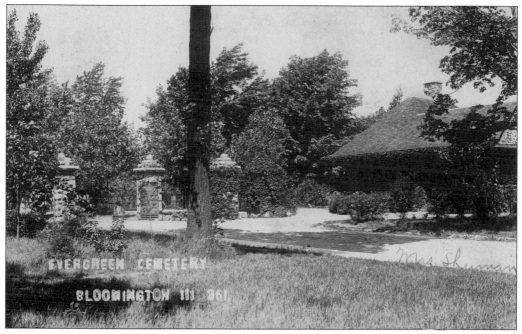

EVERGREEN CEMETERY. Located at 302 East Miller Street, the cemetery was organized in 1857. Evergreen was originally two cemeteries: the Old City Cemetery and the Bloomington Cemetery. The earliest recorded grave was in 1834 belonging to Sarah Dambold. In 1872, *The Pantagraph* suggested the new name of "Evergreen." The ashes and dust from the 1900 fire became the cinders used to harden and improve the lanes in the cemetery.

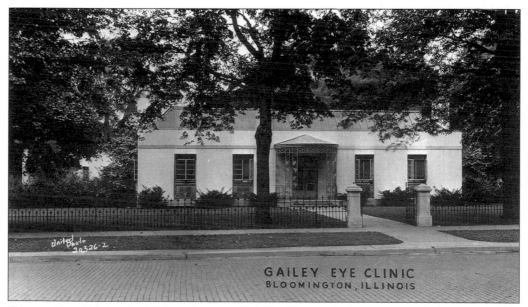

GAILEY EYE CLINIC. In 1908, at the age of 26, Dr. Watson Gailey, an eye specialist, opened the Gailey Clinic. He was a consultant in the world's first experiments in atomic medicine in Guatemala and did cataract research in India. Gailey Eye Clinic is known world-wide and the business still remains at 1008 North Main Street.

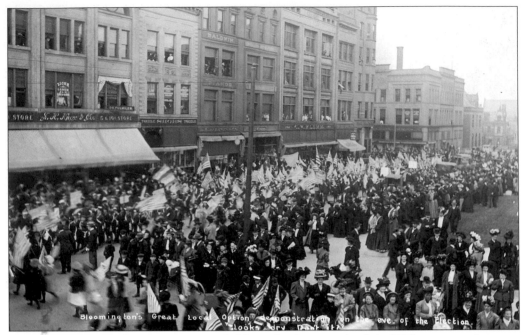

LOCAL OPTION. A demonstration was held on election eve, April 4, 1910, to persuade voters to vote dry. The view shows the demonstrators on West Jefferson Street on the north side of the courthouse. The election was statewide with communities given the option on whether to vote their town wet or dry. Bloomington voted to remain wet.

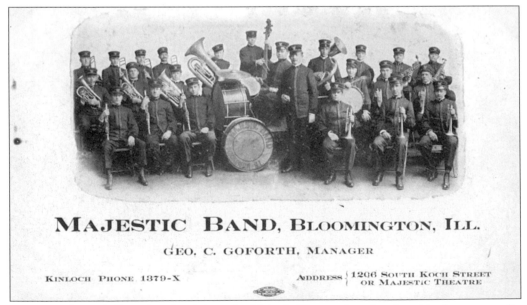

MAJESTIC BAND. They played mainly at the Majestic Theater, but also played in the community at special events, parties, and public functions. George C. Goforth was the band's manager.

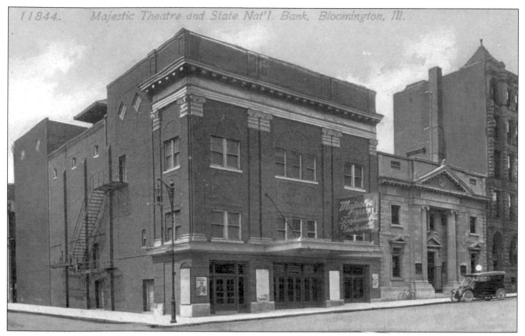

MAJESTIC THEATER. The theater opened in 1910 at 115-117 East Washington Street on the southwest corner of Washington and East Streets and many famous performers appeared at the theater. The State National Bank is to the right of the theater.

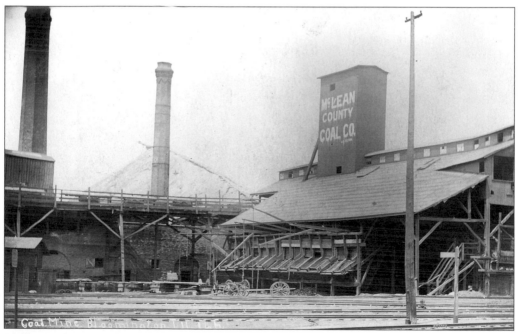

MCLEAN COUNTY COAL MINE. Organized in June 1867, the shaft was sunk near the corner of Jefferson Street and Western Avenue. At the end of 1898, a total of 130,100 tons of coal had been mined. In 1915, the output was 60,142 tons and by 1916, output had increased to 83,775 tons.

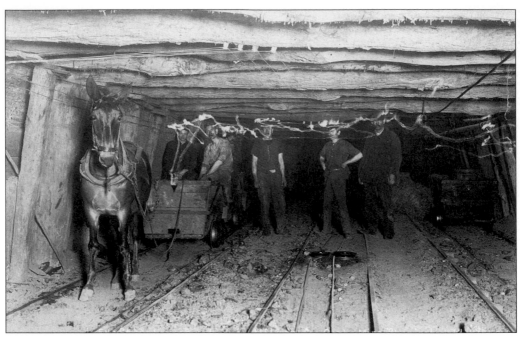

MCLEAN COUNTY COAL MINE. Mules were used for towing loads of coal, and the view shows miners and mules at 540 feet below ground. After the mine had been operating for 60 years, it closed in 1927. In 1929, the buildings and equipment were sold to Morris Tick. Four million tons of coal had been mined with a value of eight-million dollars.

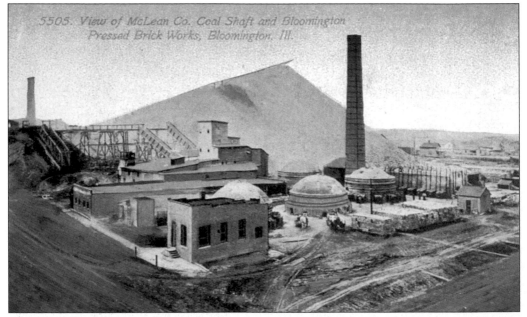

MCLEAN COUNTY COAL SHAFT AND BLOOMINGTON PRESSED BRICK WORKS. In 1890, E. Dunlap and son Oliver ran the Bloomington Pressed Brick Works. They had a daily output of 15,000 bricks and used shale from the mine to manufacture a brand of pressed brick used for building and street pavement.

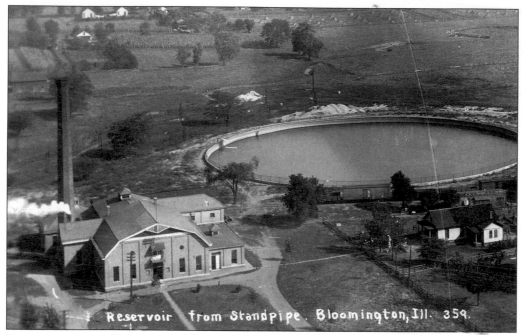

RESERVOIR FROM STANDPIPE. The reservoir was located on the northeast corner of Division and Adelaide Streets in Normal. In the summer of 1875, the standpipe was erected (200 feet high) and the engine and pump installed. Two-and-a-half miles of pipe were laid and the full system of the water works was inaugurated.

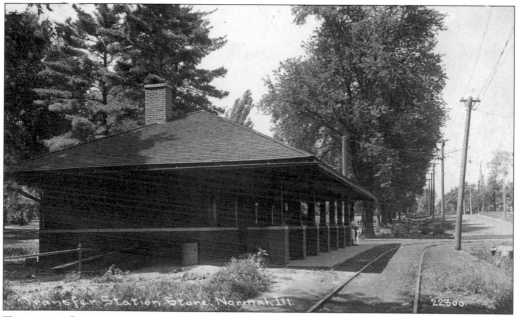

TRANSFER STATION STORE—NORMAL. The building was designed and built by John G. Coulter on the eastern edge of the Illinois State Normal University campus in 1910. The building's primary use was as a waiting shelter for passengers, but products were also sold there.

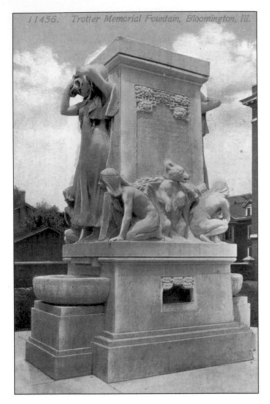

TROTTER FOUNTAIN. Lorado Taft designed the statue, which was located in the park between Withers Library and the Bloomington Club. Georgiana Trotter gave the statue to the library. Her brother, John Trotter, was a three-time mayor of Bloomington. The statue is still there today, at the same site, near National City Bank.

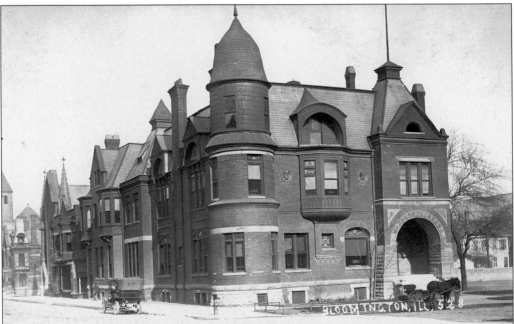

WITHERS PUBLIC LIBRARY. In 1882, Sarah Withers donated her family's home site, at 202 East Washington Street, to be the future home of a library. The library opened in 1887. It closed in 1976, when the new library opened at 205 East Olive Street.